Color In and Out of the Garden

Lorene Edwards Forkner

Color In and Out of the Garden

Watercolor practices *for* painters, gardeners, *and* nature lovers

Abrams, New York

Editor:
Shawna Mullen

Managing Editor:
Mike Richards

Designer:
Sebit Min

Design Manager:
Darilyn Lowe Carnes

Production Manager:
Alison Gervais

Library of Congress Control Number: 2021946670
ISBN: 978-1-4197-5876-8
eISBN: 978-1-64700-550-4

DISCLAIMER: The material contained in this book is presented only for informational and artistic purposes. If you use plants or flowers for any of the recipes included in this book we suggest you use only items from farmers' markets or grocery stores. If you choose to eat plants or flowers you may have found in the wild, you are doing so at your own risk. The author has made every effort to provide well-researched, sufficient, and up-to-date information; however, we also urge caution in the use of this information. The publisher and author accept no responsibility or liability for any errors, omissions, or misrepresentations expressed or implied, contained herein, or for any accidents, harmful reactions, or any other specific reactions, injuries, loss, legal consequences, or incidental or consequential damages suffered or incurred by any reader of this book. Readers should seek health and safety advice from physicians and safety professionals.

Abrams books are available at special discounts when purchased in quantity for premiums and promotions as well as fundraising or educational use. Special editions can also be created to specification. For details, contact specialsales@abramsbooks.com or the address below.
Abrams® is a registered trademark of Harry N. Abrams, Inc.

ABRAMS
The Art of Books

195 Broadway
New York, NY 10007
abramsbooks.com

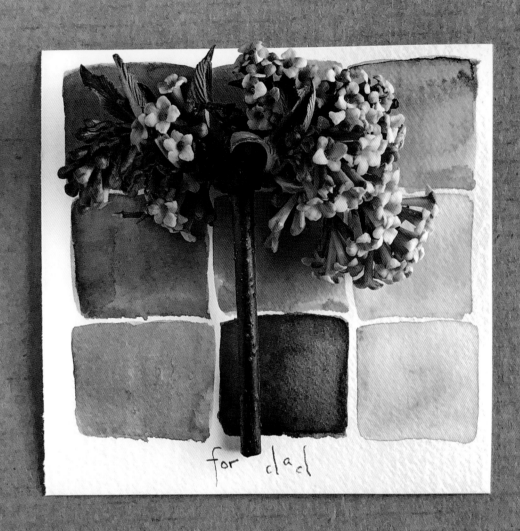

for dad

Foreword

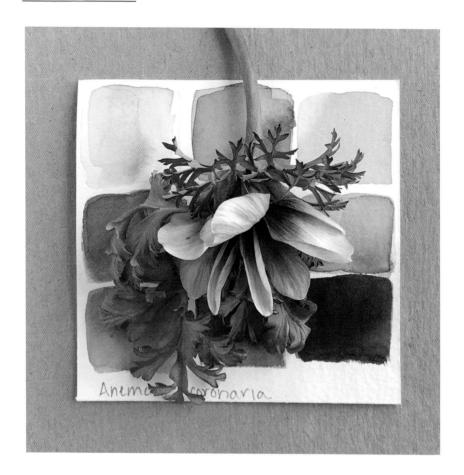

I love flowers. Much of my life is in the pursuit of finding them on roadsides, being entranced in gardens, filling my hair, and using their petals for my art. When in search for flowers, I believe that if you're looking for magic you will find it. Whether it be a lone orange poppy in a wide, barren field, or a friend whose garden is the balm your weary heart desires. I have found such magic in Lorene Edwards Forkner.

Lorene is a wonderful person to have in your corner if your obsessions lie in flowers. Having spent time hawking plants in a nursery, professionally writing about horticulture, and simply living a full, brave life has given her a wealth of knowledge and a keen eye in the garden. And her latest endeavor, analyzing and paying attention to the details of color in the natural world throughout the seasons has made her insights all the more tantalizing to receive.

One of my most memorable moments with Lorene was a hunt for bright red *Amanita muscaria*. I have my favorite spots for finding them along Green Lake,

a serene oasis in the midst of an urban landscape in Seattle. One dreary autumn Lorene very humbly asked if she could come with me to find them. I am a solitary forager for the most part. I seldom invite anyone with me on my escapades into the wilds for flowers and introverted ruminations. But Lorene is as kindred as they come in the world of natural beauty and delight of the curios of creation. We saw each other across a field, and I could see the smile and light in her eyes. Oh the delight! There was no fear of seeming silly in my all-out fangirling of this marvelous mushroom that evokes feelings of Baba Yaga and gnomes and faerie wonder. Lorene tromped with me into eerie forest and along murky shore to catch a glimpse of their bright pops of color against the gloom. A much-needed escape from the gloom I had been feeling during that season of my life.

That is the magic of color, and Lorene bottled it up and mixed it with paint. With her paint brush as wand, and open, curious heart as conjuring spell. Sure enough, one of the *Amanita muscaria* mushrooms made its way into her color studies, along with so many other finds, that I can only imagine involved just as much soulful examination and joyful selection. I have gasped on more than one occasion at her latest works. She says she's not an artist, that she only wants to "slow down and see, pay attention." But if that's not the marrow of a work of art, what is? To have a photograph or smudge of paint absorb the soul of an object and help you see it fully? That is a rare gift.

The first time we met, Lorene invited me to her garden to interview me for an article she was writing. I admit I am fairly nervous about these types of interactions, ever battling my social anxiety. But she asked if I ever used bugs or creatures in my art, and promised I could pick the prettiest snails from her garden. My curiosity about a woman who would offer another person snails won out, and I am grateful that it did. Her garden was a feast for the eyes. She had expertly crafted a space that was welcoming and intriguing. I was immediately drawn to look closer and touch what I saw. We sat in a cool, open structure placed perfectly for viewing her plants. I had so many questions about the different projects she was working on and plants she had nurtured, but my favorite thing of all about her garden was her use of color.

What sticks most enduringly in my memory is purple and chartreuse. At that time she had selected plants with leaves in variegated maroons and greens, flowers with fluffy purple frills and starry amethyst explosions. The sense of symmetry and poetry her garden evoked in me tickled my soul. She sent me home with an armful of flowers and a new understanding for the attraction of opposite colors in nature. How is it that something so simple as a flower can make us feel so complex? A slice of infinite in the finite . . . that's what the garden brings. And Lorene has captured it.

Here is a sage who not only will offer you her prettiest snails, and be enamored with *Amanita*, she will infuse your world with her innate wisdom for color. We are so lucky to have the magic she's distilled from her finds at our fingertips.

Bridget Beth Collins
Author, The Art of Flora Forager, *and on IG @floraforager*

Contents

Preface:
Seeing Color in the Garden

Color is about seduction. It is both a delightful gift and one of nature's most sophisticated tools engineered to capture the attention of all living creatures. While the allure of color is powerful, our response to it is deeply personal.

For decades I resisted calling myself an artist, even though my background is in painting and textiles.

I am a gardener.

Making a garden is like being inside a work of art as it's being created. I paint pictures with plants, sculpt the landscape, and choreograph an experience. And I get berries!

The garden is my medium and color is my muse, from the pastels of spring to the saturated hues (and flavors) of summer. I like to say that color is my native tongue, a common language that crosses all borders and barriers. I am a horticolorist, if you will. Plotting and planting, I fill my days with color throughout the wheeling seasons.

Watercolorist Mimi Robinson uses color to record time and place. An exhibit of her work at the University of California Botanical Garden at Berkeley, specifically a colorful grid depicting the range of pink, rose, plum, wine, and charcoal hues that she identified in a sprig of blossoming plum, blew my mind wide open. Seeing an object from nature represented as pure color moved me. This encounter in a rustic exhibit space buried deep within a garden would prove to be foundational.

I have always longed for a daily practice, a fixed habit to provide structure and discipline, a framework and a through line for my days. To my everlasting dismay, I can't seem to sustain a regular exercise routine. A sitting meditation? Not damn likely. Maybe, I thought, I should keep a journal—in those hours when I'm not digging and planting, watering and weeding, I'm a writer and an editor.

As we all know, life is complicated, messy, and, on occasion, given to fully coming apart at the seams. A few years ago, in the midst of a particularly harsh roller coaster of chronic sorrow and loss due to family health challenges and a shift in economic security, to say nothing of a caustic political scene, I became a very human stew of anxiety, fear, and depression. And then my father died.

I was gutted.

The 100DayProject is a global community of accountability and encouragement. Every year, people from all over the world commit to spending one hundred days exploring their creativity and publicly sharing

their efforts on Instagram. That spring was to be my third time participating in the 100DayProject. I wanted to keep my streak going, but I was in no condition to tackle anything ambitious.

Inspired by that plum blossom palette by Mimi Robinson, and in an attempt to create an iterative project that would simply tell me what to do, I decided that for one hundred days I would pluck a piece of my garden and try to reproduce the colors in the botanical in swatches of watercolor. I set simple parameters, with what I hoped would be minimal barriers to success. I vowed to be gentle with myself, to forgive falling short, provided I continued to follow through.

In April, I posted a watercolor study of a blossom of *Viburnum × bodnantense* 'Dawn' and wrote: "These days life is charged with loss and grief. But if I'm honest with myself (and desperately trying to keep on keeping on) I have to acknowledge that without great love, there would be nothing to grieve. My hope is that this daily interval focused on seeing and my beloved garden will provide refuge and a way forward."

The garden is a relatively gentle proving ground for encountering love (and no small measure of lust) along with heartbreak, loss, death, and plenty of tedium—excellent training for navigating life and grief. So began my Seeing Color in the Garden project. The practice was transformative. I learned that nature is a balm. Love and loss are inextricable. And nothing really ends.

Now, several years later, what began as my attempt simply to show up for an online challenge has become essential, a meditative daily exercise that quiets my mind even on days when my clumsy attempts frustrate me and fall short of depicting what nature does so elegantly.

Constantly foraging for color has taught me to be mindful of and accept my own cycles of attention. Some days flow with an almost audible chime. Others produce nothing but noise and a tiresome repetition that just about does me in.

Usually, the doing of it is enough. And there's always tomorrow . . . and the day after, and the one after that. Though not necessarily any easier, my practice has become second nature—a virtuous cycle that prompts me to slow down, focus, and cultivate awareness.

How we direct our attention matters.

I seriously doubt that I'll ever pin down every color I see. Like the sun and light itself, the source of all color, my practice is in constant motion.

Lorene Edwards Forkner

Introduction: Learning to See

My garden is the lens through which I see the world, it connects me with natural systems and underscores the importance of how I respectfully consume and manage resources. It's also a living palette of plants, soil, wildlife, and microorganisms.

Since I began collecting and recording the colors that I see in my garden, I've begun looking more expansively at the world around me. Tending my garden allows me to sync my entire being with time, not just the current season or even a particular day, but the present moment. When my senses are dulled by artificial lighting and the cacophony of daily life, my garden grounds me; it reminds me that I am a human animal and a part of nature. **This book is about plants and color and being mindful. It's about looking out and looking in.**

In recording color, I'm engaging with reality in a new way.

Color In and Out of the Garden holds the compiled evidence of my daily practice devoted to color and mindfulness. My watercolor studies log life and the landscape in every hue and season, and I hope, in these pages, to encourage you to do the same—to tap into an intimate relationship with your garden and feel the healing power of connecting with nature. Arranged by color, the chapters present plant profiles, personal reflections, and creative prompts that trace the process of learning to focus attention (red) and energy (orange), the exploration of memory (yellow) and growth (green), and the willingness to remain vulnerable or tender (blue) and always to choose love (violet).

This is an exercise not in botanical illustration but in learning to see. As you read—and, hopefully, pick up a brush yourself—try to approach each color study with a fresh perspective. Whether you decide to adopt a daily practice, or simply want to slow down and savor the season, this is an opportunity to quiet your thinking and to focus, a mindful meditation where color is our mantra, a willful distraction to direct our attention.

In sharing the following collection of color studies and observations, my rainbow playground, I hope to open your eyes and deepen your compassion for beauty in the natural world.

But first . . . what's your favorite color?

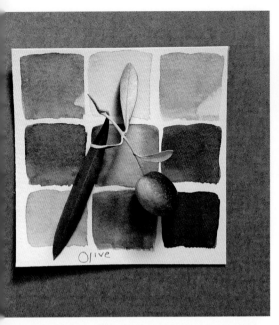

Olive

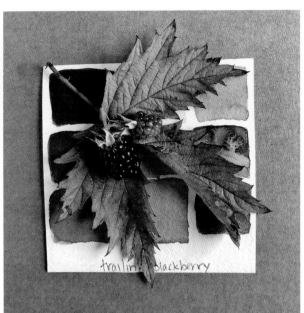

trailing blackberry

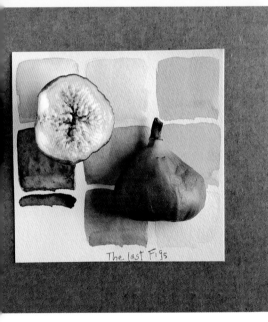

The last Figs

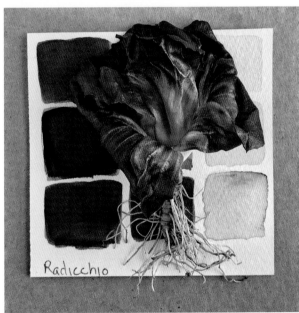

Radicchio

The Nature of Color

What Is Color?

How do you learn to really see color? What, in fact, is color?

According to physics—the branch of science that deals with properties of matter and energy—color is light and vitality. It's been written that all of creation began with light. Certainly, colors need light to activate their energy. Yet light is fluid, constantly changing by the hour, from season to season, and even depending on where you are in the world. This makes color slippery, an ever-changing, almost sentient presence in our environment.

Or does color reside in perception? That would be the neurobiological interpretation: Color results from our brain decoding electrical impulses from the rods and cones in our retinas.

Flexing our perception helps us reframe the familiar. So, when you sit down to create a color study, try to put away assumptions and concentrate on seeing what is right in front of you. To forget, just for a moment, what you think you know. A red rose, a green leaf, even a humble radish all contain almost infinite subtleties and nuance.

There's a delightful feedback loop to identifying color. The more we look, the more we see. The more we distinguish, the greater our ability to discern further detail. The generosity of our attention enlarges our perception.

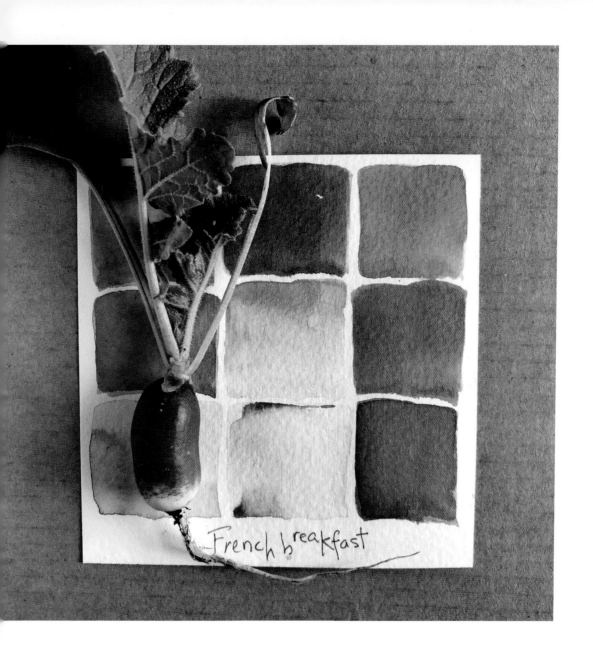

French breakfast

The Nature of Color

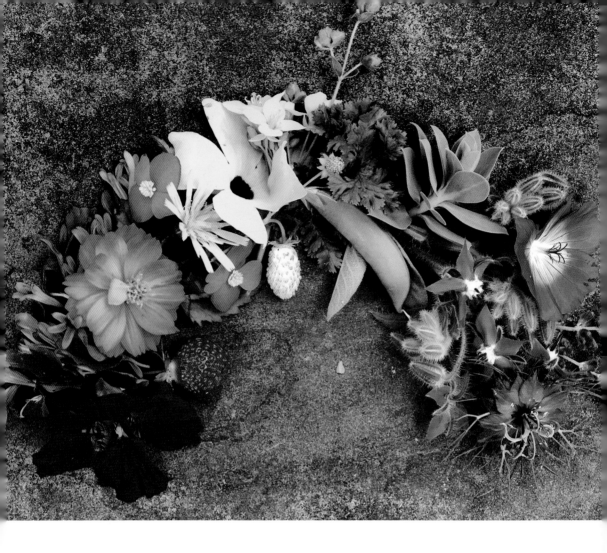

Roy G. Biv

A rainbow is simply an expression of light in an atmosphere of moisture. Nevertheless, most of us are captivated by the sight of a sky filled with color, we're lifted to the heavens and at the same time grounded by a reflection of the curvature of our planet. As a child, I learned the mnemonic Roy G. Biv for the order of colors as they appear in a rainbow. Yet a rainbow isn't made up of just red, orange, yellow, green, blue, indigo, and violet. It's actually a smooth gradation of countless colors in which each hue blends seamlessly with the next, constantly in motion, reinventing itself as light strikes each individual raindrop.

Colors don't sit still, you've perhaps noticed. Depending on their placement, colors flow, bounce, vibrate, or hum. So, for the sake of putting a pin in this evanescent topic, let's introduce the terms commonly used to define and describe color.

Hue refers to a color itself, while saturation describes the intensity of that color, easily expressed in watercolor by the degree to which you dilute a pigment with water.

A color wheel is an abstract depiction of a color's relationship with other colors.

Blue, red, and yellow are known as primary colors—that is, they are made only of themselves—and are often referred to as the building blocks of all other colors.

Secondary colors are what you get when you mix two primary colors together, for instance, blue + red = purple; blue + yellow = green; red + yellow = orange. When you mix a primary color with a secondary color adjacent to it on the color wheel, the result is a tertiary color. So yellow (a primary color) and green (a secondary color) combine to create yellow green, a tertiary color.

Color expressed in various tints and shades of itself is said to be monochromatic; picture all the shades of indigo in a comfortable pair of well-worn denim jeans. Analogous colors are three colors next to each other on the color wheel that combine with ease, a harmonious variation on a multicolor theme.

Complementary colors appear opposite each other on the color wheel—red and green, for instance. Optically, complementary colors vibrate with intensity when placed next to each other. But when mixed together, complementary hues diffuse each other, shifting and nudging colors in wonderful directions.

While these paint box definitions of colors are tidy, attempting to work with them quickly exposes the gap between theory and practice. Color in nature is rarely pure. It's only when we venture beyond the scope of a color wheel and let our paints mix and blend that we can begin to see—and capture—abundant color.

Color in the Garden

Color is the most obvious element of a garden and an essential tool in the creation of a pleasing landscape. In nature, color is a vital component of pollination, ripening, and other biological processes that are fundamental to life. Yet, from a human perspective, color is often treated as simply surface decor—an afterthought or, at best, a slightly indulgent finishing touch. Still, as in the case of a bowlful of berries that've been sugared to draw out deeply flavorful juices and topped with a dollop of cream, we know that sometimes a finishing touch can be transformational.

As gardeners, we can use color and place plants to manipulate space, harness time, and leverage light to spectacular effect. Pastels, those colors that are infused with light or tempered by white, appear to advance in the landscape and illuminate shady corners. Placed at intervals throughout a border, these bright spots create a rhythm, drawing our eyes from one plant to another; they lead us visually through the space. As dusk falls, colors transition to contrast. Shimmering white and light-colored blooms pick up the sunlight bounced off the surface of the moon—a bit of celestial wizardry that gardeners can use to animate the night garden. Darker, less reflective shades, like deep red, plum, or dark blue, recede into shadows and vanish as the day's light gives out.

In nature, complementary colors are purposeful. A golden spot at the center of a violet pansy creates a contrast that directs foraging pollinators to the blossom's nourishing pollen and nectar.

The natural world is *very* colorful. A traditional color wheel doesn't begin to describe the variety of hues found in even the smallest plot of land, but it's a good place to start. Some of my favorite shades, like pink, brown, gold, aqua, indigo, and wine, while related to color wheel hues, are grounded in nature and hint at the multitude of colors awaiting discovery.

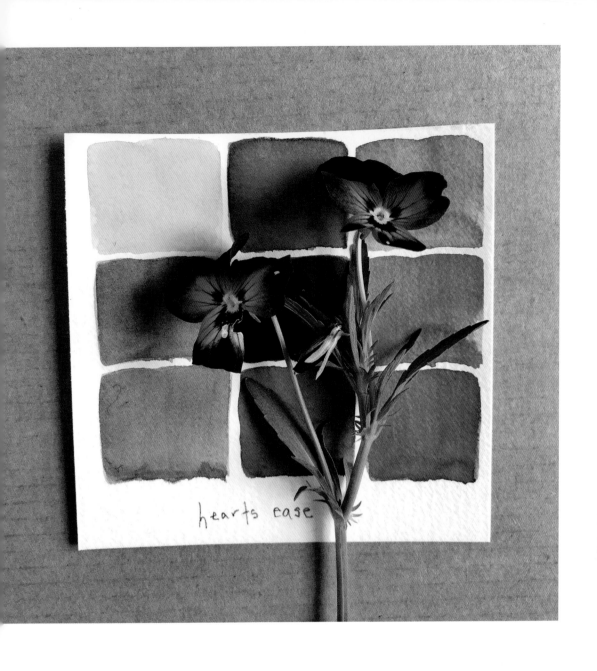

hearts ease

The Nature of Color

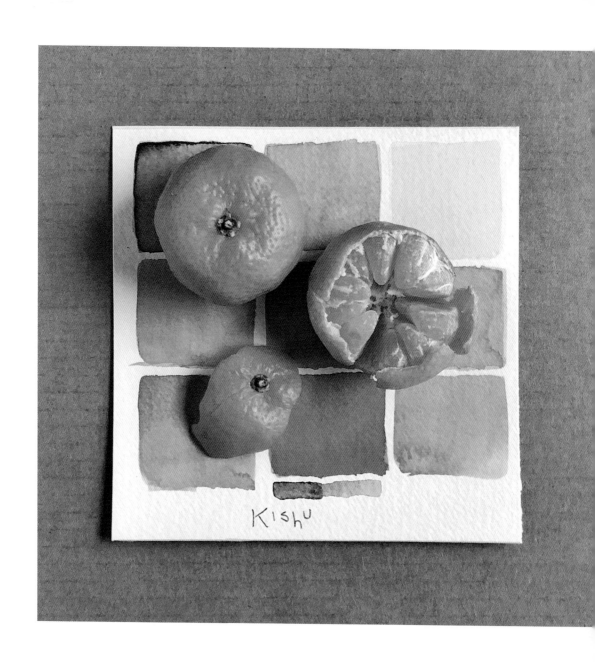

The Name Game

Typically, a color is defined . . . by its color. A generally accepted, if somewhat circular, logic lacking scientific rigor, imagination, and romance, in my humble opinion. Have you ever tried to remember a color? It's nearly impossible. But when color, memory, and association collide, our fluency with color improves. And for that we need language.

Naming expands and specifies our perception of color. And it's fun! What's more, naming colors puts us into a conversation with others. For instance, if you say "orange," we both probably picture an orange that is the color of an orange. But if you say "peach," "apricot," "tangerine," "melon," or "pumpkin," all of a sudden you've helped me to "see" various expressions of what is still basically orange. I never tire of this word game that, along with my color studies, deepens my appreciation for degrees of nuance.

Red

Blush	Cranberry	Beet	Fuchsia
Cerise	Apple Blossom	Bordeaux	Scarlet
Watermelon	Rose	Ruby	Hibiscus
Fruit punch	Raspberry	Poppy	Garnet

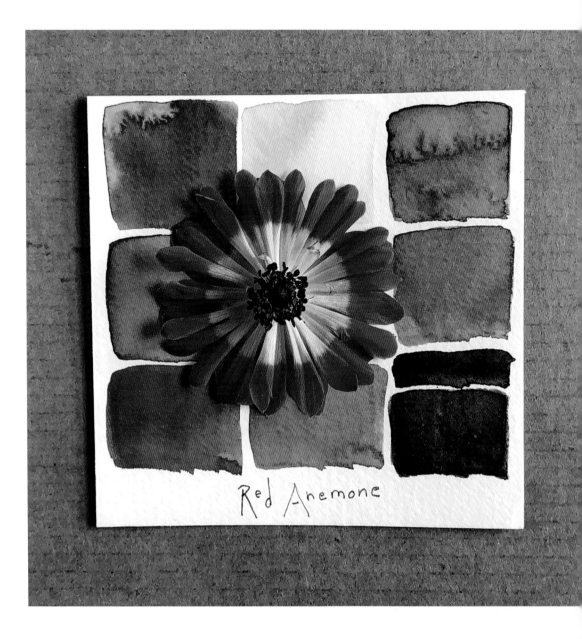

Red Anemone

Poppy anemone
(Anemone coronaria)

Perennial but often grown as an
annual in cutting gardens,
8 to 10 inches (20 to 25 cm),
full sun, zones 7–10

candy apple
poppy
carmine
clown nose
cherry
ink

Rite of Spring

Sassy red anemones glare among other blooms in, shall we say, less strident tones. They beg to be picked if for no other reason than to soothe an otherwise harmonious planting of maroon, lavender, rose, and pure-white blossoms.

Every fall, in a gift to my future self, I plant a large agricultural trough with as many wrinkled brown, frankly not-very-promising anemone tubers as I can lay my hands on. I intentionally don't include red varieties, but errant plants inevitably show up: *Look at me!*

Blossoming stems begin unfurling in early spring from a base of frizzled parsley-green foliage, and each plant continues to bloom for months. Keep up with picking the flowers, and the plants will continue to produce more, allowing you to share posies with family, friends, and neighbors. <u>A floral expression of love and generosity prompted by abundance,</u> a personal rite of spring.

Lipstick Red

The naming of colors, or what we collectively reference to describe and define them, enlarges and enriches our perceptions. There's nothing subtle about red in the garden, or anywhere else for that matter. *Potentilla* 'Volcan' evokes matte lipstick and sultry sophistication. Velvety sanguine petals, shadowed with hues of antique wine and garnets, contrast with the plant's silvery green foliage.

In the garden, distance and low light turn dark red into a black hole. Keep 'Volcan' and other plants with similarly dusky hues nearby, along pathways and border edges, where they will be seen and can be examined intimately.

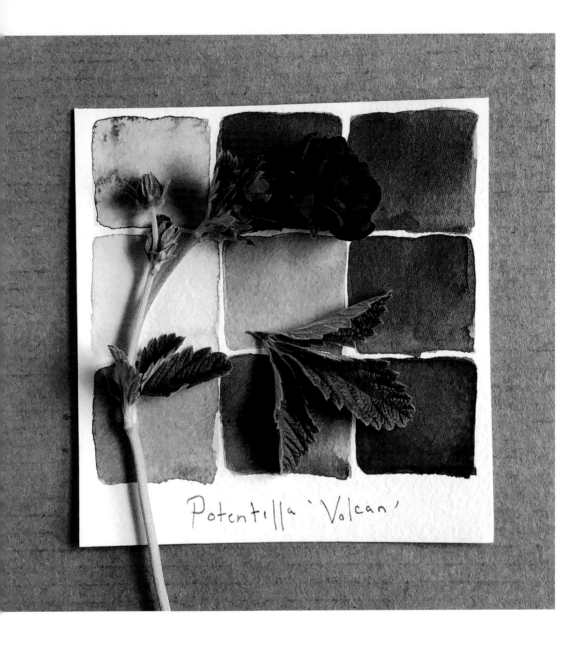

Potentilla 'Volcan'

'Volcan' cinquefoil
(*Potentilla* 'Volcan')

Perennial, 18 inches (46 cm),
full sun, zone 5

antique wine
garnet
ruby
bone
olive
tarnished silver

Red

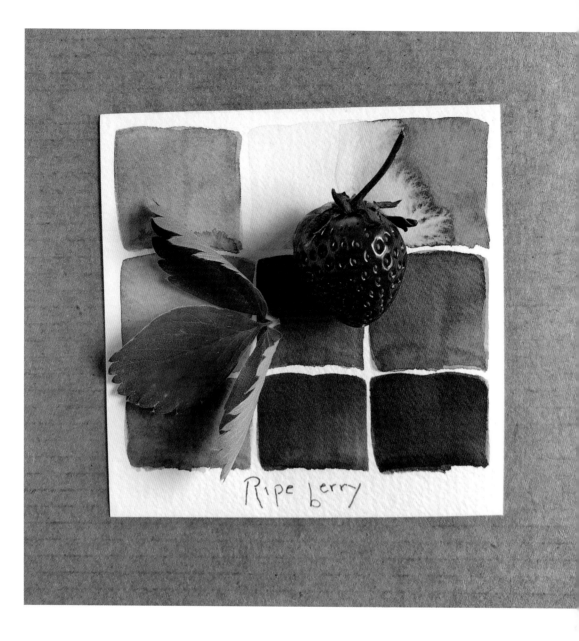

Ripe berry

Strawberry
(Fragaria × ananassa)

Perennial,
4 to 6 inches (10 to 15 cm),
full sun to part shade, zone 4

ruby
scarlet
crimson
berry
moss
aloe

Protecting Pleasure

Strawberries, heavy with perfume and ruby to the core, the sure sign of peak perfection, are a delicious pleasure. Honing my senses to detect squawking crows, while keeping an eye out for neighborhood rabbits and marauding snails, I monitor and defend my patch with the devotion of a new mother.

While I generally steer clear of red blossoms in my ornamental beds and borders, red is one of my favorite colors when it appears in the edible garden.

Red signals ripeness and nourishment. The perfect complement to green, the fruits appear in high contrast to their surrounding foliage, providing a visual target for pollinators, browsing animals, and gluttonous backyard gardeners.

Pretty Tasty

With gorgeous good looks and an easy disposition, rhubarb belongs in every ornamental garden. A vegetable that's typically treated like a fruit, rhubarb has red or green or red-and-green stalks that bring mouth-puckering tang and tart freshness to sweet and savory dishes alike. From crisps and crumbles to a garden-forward cocktail or saucy barbeque, rhubarb announces the end of winter and the beginning of a new growing season. While the flavor profile of rhubarb varieties is nearly identical, red-stemmed rhubarb lends a visual rosy juiciness that I've tried to capture by mixing various watery shades of warm pink and the deep crimson of an embarrassingly red ripe strawberry, a traditional rhubarb kitchen companion. A pale green stem grounds the palette firmly in spring.

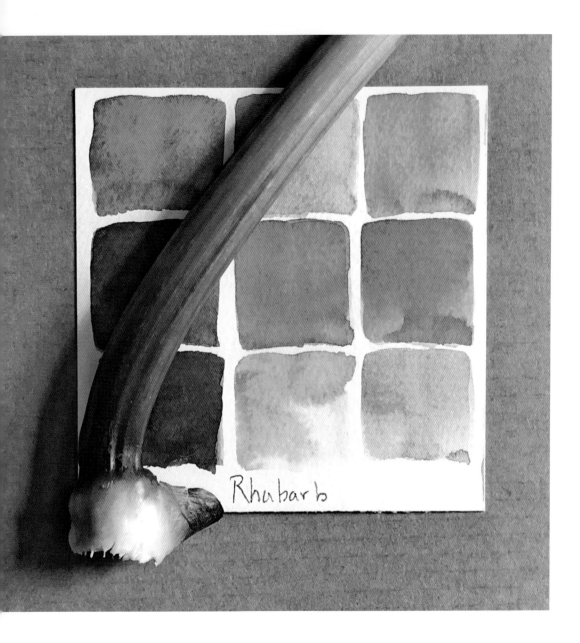

common rhubarb
(*Rheum* × *cultorum*)

Perennial, 3 to 4 feet (.9 to 1.2 m),
full sun, zones 3–7

watermelon pink
strawberry
crimson
merlot
blush
stem

Red

Rhubarb Shrub

Like spring in a glass, this refreshing drink combines tartness and garden sweetness to bring out rhubarb's bright flavor.

2 pounds (1 kg) fresh
 *rhubarb**
1½ cups (210 g) sugar
A few ripe strawberries
 (optional)
1½ cups (375 ml)
 Champagne vinegar
Sprig of fresh rosemary

Remove leaves and trim any dried ends from your rhubarb before finely dicing each stalk.

Combine the rhubarb and sugar in a nonreactive glass bowl, cover, and allow to macerate in a cool place for 24 hours. Spring is rhubarb season, so room temperature on the countertop should be fine unless you live in a very warm climate. If you're looking to lean decidedly pink, add a few red ripe strawberries to the mix and mush everything together.

When you come back to the mixture, you'll find the sugar has drawn out the rhubarb's juices and dissolved, creating a clear pink syrup. Press on the rhubarb to encourage it to give up its all, but do not strain.

Add the vinegar to the rhubarb-syrup mixture, stir to combine, and chill, covered, in the refrigerator for 8 to 12 hours. Chilling even longer allows the flavors to develop and soften. Taste periodically to note the difference.

When you can't wait any longer, using a fine sieve, strain the mixture into a pitcher, pressing to get every last drop.

To serve, mix 1 part shrub with 1 to 2 parts sparkling water. Serve over ice garnished with a sprig of fresh rosemary. This is also delicious spiked with a floral gin for a garden-forward cocktail enjoyed on the first warm day in May.

**Tip: Red rhubarb yields a more brilliant pink shrub, though green is delicious, too.*

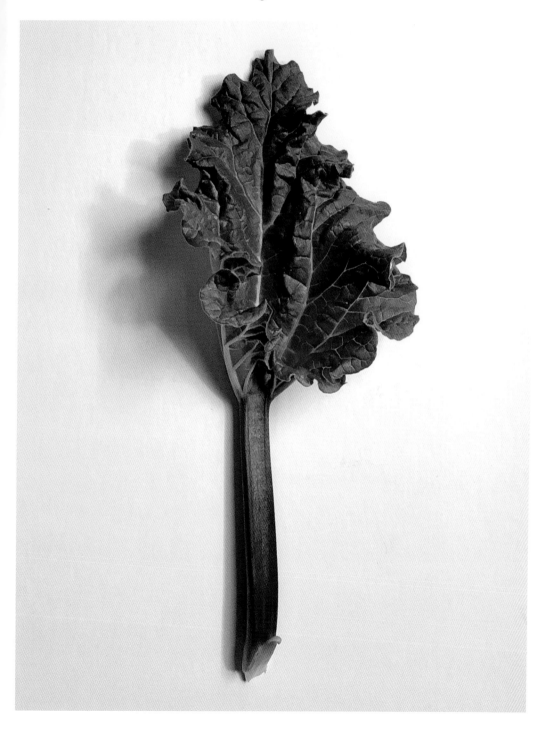

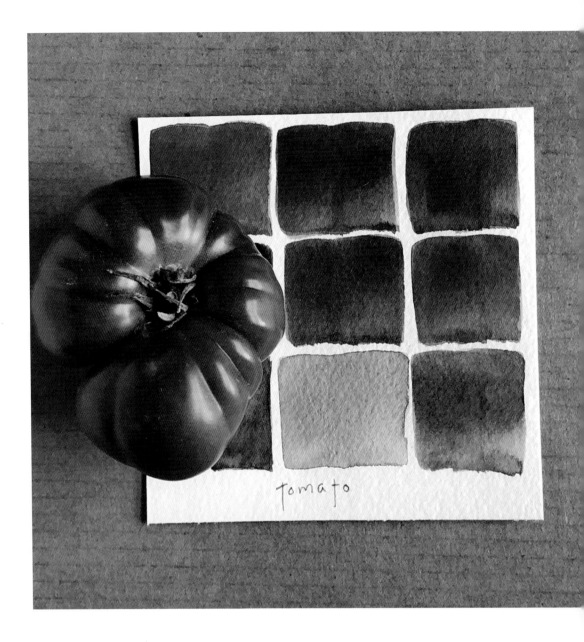

tomato

Garden tomato
(Solanum lycopersicum)

Perennial grown as an annual,
size varies, full sun, zones 10–12

flame
scarlet
crimson
mahogany
cherry
kelp

Recognizing Ripeness

During months of tending, gently tying the sticky fragrant foliage to stakes and lifting the plants just that much closer to the sun, eager gardeners monitor the developing fruit as summer progresses. Yet biting into the first tomato that blushes red, we are often met with disappointment, tasteless flesh, and a mealy texture. But given a bit more time, red deepens to crimson, scarlet, and even a burnished mahogany, producing a ripe garden tomato with deep, satisfying flavor and a spicy aroma.

There's a patient art to recognizing ripeness.

Fireglow

Observation is one of the sharpest tools in a gardener's kit—and, incidentally, the only one that can never be misplaced. Noticing reveals the previously invisible. The more you look, the more you see. Which prompts a curiosity to look even more closely.

Diminishing daylight in autumn slows down the production of chlorophyl as plants enter dormancy. As the green recedes, the leaves on deciduous trees and some perennials, especially this *Euphorbia griffithii* 'Fireglow', display brilliant color as latent pigments— xanthophyll (yellow), carotenoid (orange), and anthocy- anin (red)—are revealed. It's time to dabble in glowing sunset hues.

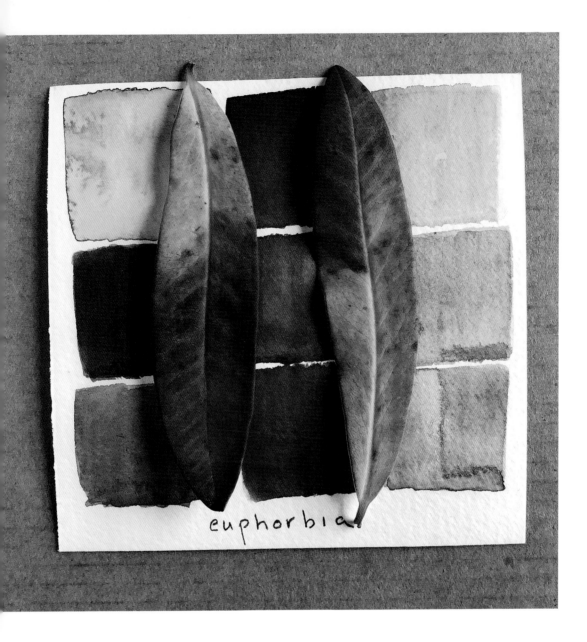

euphorbia

'Fireglow' spurge
Euphorbia griffithii
 'Fireglow')

Perennial,
24 to 36 inches (61 to 91 cm),
full sun to light shade, zones 4–9

flame
crimson
carmine
citrine
chartreuse
kelp

Red

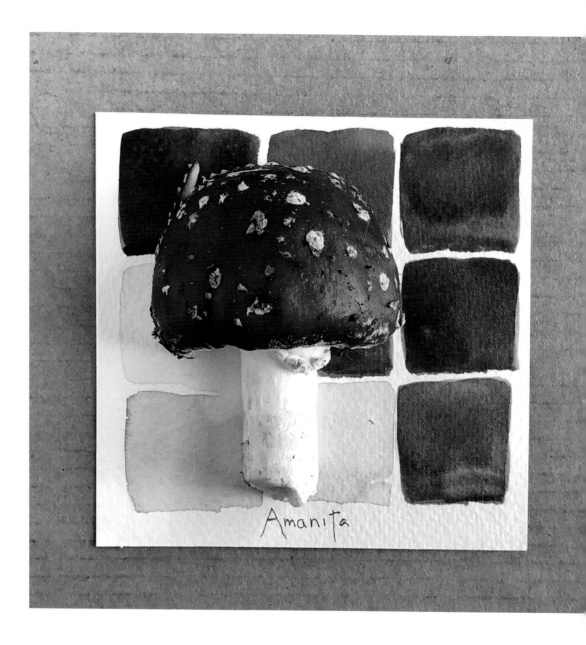

Amanita

Fly agaric
(Amanita muscaria)

Mushroom,
2 to 8 inches (5 to 20 cm),
grows in mycorrhizal symbiosis
with various woody plants

scarlet
carmine
ruby
bone
oyster
linen

Natural Wonder

Amanita mushrooms, often associated with grumpy trolls and frolicking woodland creatures, figure in fantastical stories that lodge in our imagination and follow us through life. White-spotted red caps and hookah-smoking caterpillars hint at magic and menace not of our everyday world.

So imagine my delight when a friend pointed out numerous colonies of this iconic toadstool growing in tall grass at the bases of trees lining a well-trod pathway in a nearby park. Grounded in seasonal rhythms and a symbiotic relationship with other plants, this natural (and poisonous) wonder was hidden in familiar territory all along.

Befriend your attention. Seeing expands our reality and revises, sometimes alarmingly, what we think to be true.

Seasonal Rhythms

Rugosa roses are constant and sturdy companions in the garden, unfussy and independent, with powerfully fragrant blossoms in summer. As the growing season winds down, their fat scarlet hips signal a resistant flickering flame in the face of the coming cold.

The garden teaches us endurance. Every year is different. Conditions change, we change. With luck, we will get another chance to plant, replant, experiment—and possibly fail—and try again.

Creating a journal of tiny paintings is an act filled with wonder and celebration: Examining nuance and detail helps claim possibility. Capturing the colors of your garden allows you to hold this moment against the winter months ahead.

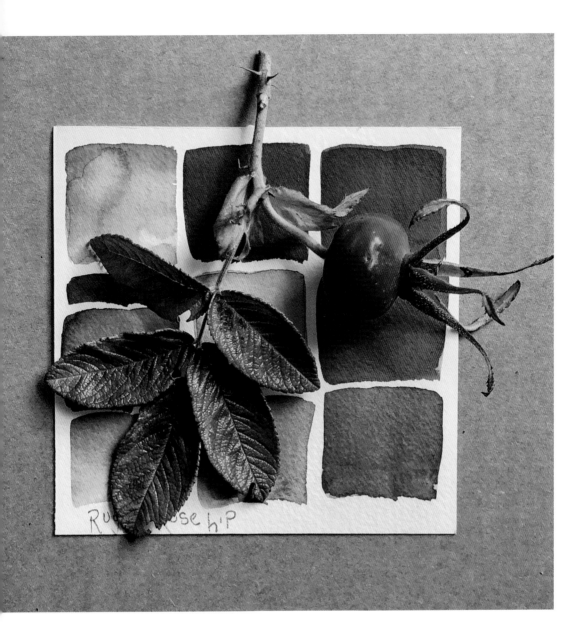

Rugosa rose hip

rugosa rose
(*Rosa rugosa*)

Woody shrub,
4 to 5 feet (1.2 to 1.5 m),
full sun, zones 3–9

vermilion
tomato
rust
bottle green
bronze
aloe

Red

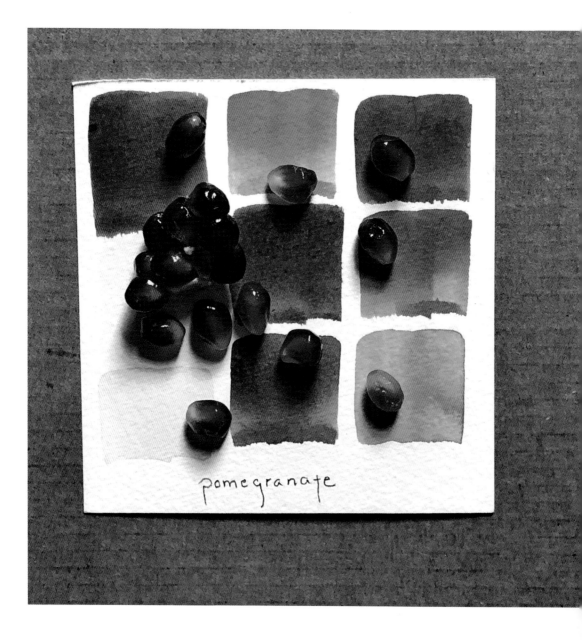

pomegranate

Pomegranate
(Punica granatum)

Deciduous shrub,
12 to 16 feet (3.6 to 4.9 m),
full sun, zones 7–10

ruby
scarlet
crimson
garnet
cranberry
blush

Pomegranate

Mourning is nothing new; it just feels that way to the soul who has lost a beloved.

Persephone, daughter of Demeter, the goddess of the harvest—some say Mother Earth—was seized by Hades and taken to the underworld, where she was tricked into eating several pomegranate seeds (symbolizing marriage and fertility) and was thus consigned to remain forever with Hades. In raging grief, Demeter made the earth barren. Only when Zeus intervened and allowed Persephone to visit her mother for part of the year did the earth turn fruitful again. The seasonal rhythms of Persephone's annual arrival and departure govern the garden to this day.

My decidedly less dramatic response to the death of my father was to begin documenting colors observed in the natural world. A daily interval focused on seeing, a mindful distraction from pain and heartache. It was late winter. Ripe pomegranates filled bins at the market.

Pink

Pink is an enigma. While the color is not found on the visual spectrum of light, dark pink—or magenta—is one of the most commonly occurring flower color in nature. Pink gets its name from flowers in the genus *Dianthus*, commonly known as carnations or pinks, a reference to the serrate, or "pinked," edges of the delicate, fragrant flowers.

I'm pretty sure that I began gardening so I could pick flowers with impunity. Once, on the way to school in the second grade, I gathered a small posy of garden pinks, an offering to my teacher. Miss Mogus reprimanded me in front of the entire class for stealing flowers. I was mortified.

Sakura is the Japanese word for cherry blossom. The moment when you are walking along a sidewalk and the blossoms begin to shatter and shed their petals is called "*sakura* snow"—a botanical representation of the ephemeral nature of life. Circumstances have made me keenly aware of the perils of life. But an extravagant show of pink petals is a marvelously generous and reassuring reminder that beauty prevails even when everything else is off kilter.

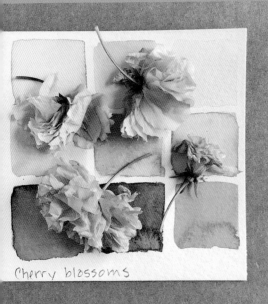

Cherry blossoms

Pinky

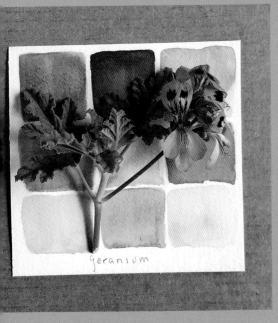

Geranium

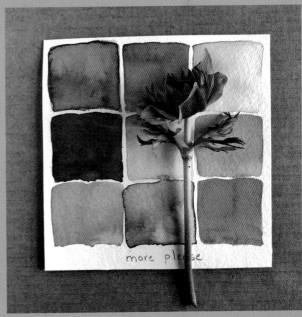

more please

Chapter 3

Orange

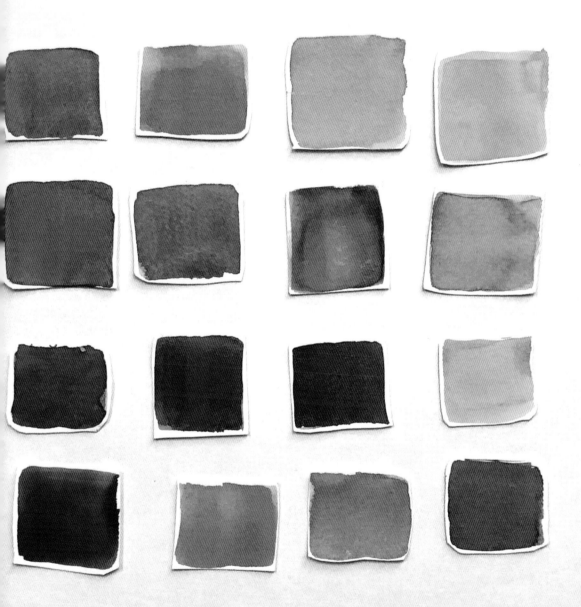

Amber Carrot Cheddar Tangerine
Coral Rust Caramel Salmon
Pumpkin Marmalade Flame Mclon
Saffron Papaya Peach Sienna

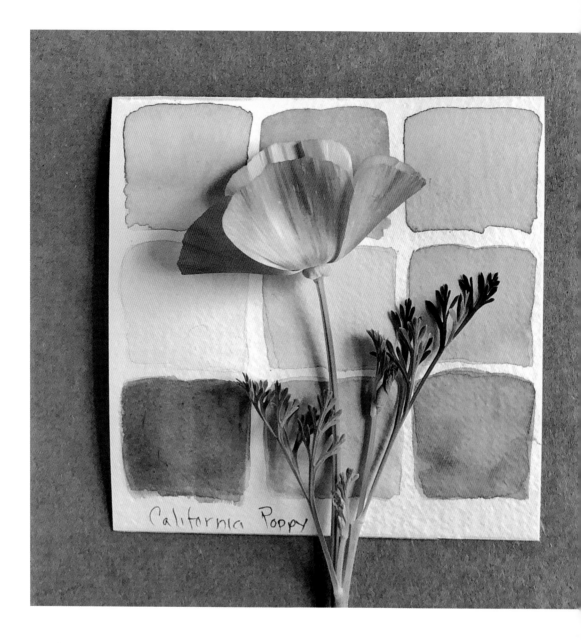

California Poppy

California poppy
(Eschscholzia californica)

Perennial,
8 to 12 inches (20 to 31 cm),
full sun, zones 6–10

peach
apricot
melon
coral
shell
grass

Transformation

A simple California poppy growing in gravel or dry scrub boggles the mind, when you really think about it. That a seed barely bigger than the period at the end of this sentence should become, in a few short months, a sherbet-popsicle-colored bloom strains credulity. But that's merely the beginning—a showy display designed to lure attention and invite engagement.

As foraging bees pollinate each flower, the plant is triggered to produce long spindly pods filled with dozens of tiny seeds, near replicas of that first tiny scrap of genetics.

In essence, a garden is a stage set for the transference of energy, a window onto the process on which our planet relies. From seed to plant to bloom to insect and back to seed again. Transformation powered by the sun—ephemeral, abundant, and constantly self-renewing.

Go Outside

Supposedly, the Swedish filmmaker Ingmar Bergman once said, "Demons hate fresh air." I couldn't agree more. **The garden is the best escape from the stress of everyday life.**

One day, while shopping at the farmers market, I picked up a bunch of 'Princess Irene' tulips. It was an unusual variety, with squat stems, among all the other graceful long-necked beauties, but its marled coloring, citrus and red wine, sunlight and shadow, appealed to me.

Play a little mind game with your finished painting: Try shifting your perspective from an intimate look at the colors to a bird's-eye view of an imagined land-scape. This one is sunset in a warm land filled with lush foliage and ripe fruit. Botanical travel.

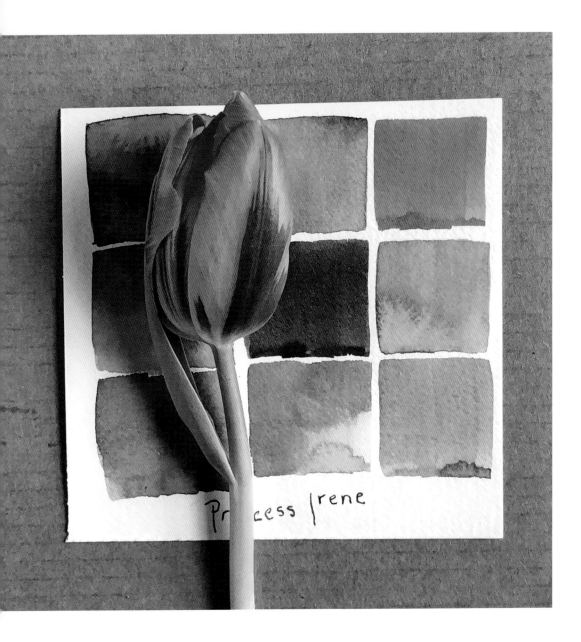

'Princess Irene' tulip
(*Tulipa* 'Princess Irene')

Triumph tulip,
15 to 18 inches (38 to 46 cm),
full sun, zones 3–8

paprika
sunset
cumin
merlot
aloe
moss

Orange

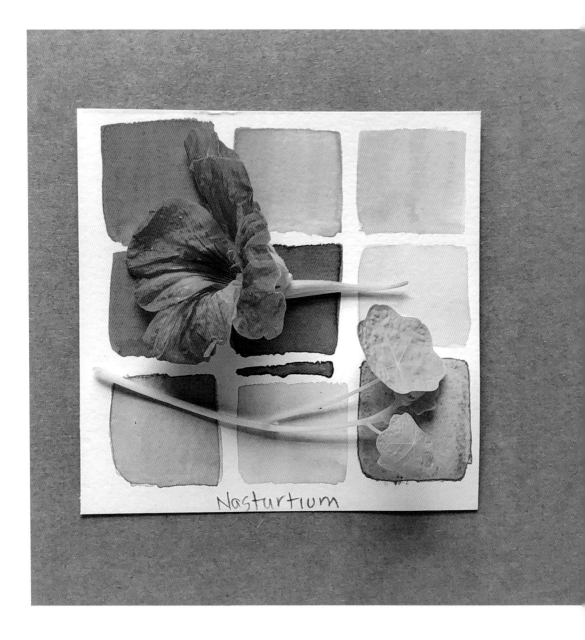

Nasturtium

Nasturtium
(Tropaeolum majus)

Annual,
size varies,
full sun, zone 9

orange
sunset
tangerine
banana
lime
aloe

Cultivating Childhood

Perhaps you were like me as a child, reading *Little House on the Prairie* and dreaming of living off the land. When I was a little girl, I was aware less of cultivating than of harvesting nature—foraging for blackberries and biting off the tip of a nasturtium blossom's spur to get at the tiny drop of sweet nectar.

Planting is a serious leap of faith for any child with a shiny brown seed that looks nothing like an apple. But all of us who were early garden supplicants found faith: We've been kneeling in the garden ever since.

Totally Tangerine

Sometimes, the colors you choose for your garden can act as a kind of spirit guide: Orange is mine—energetic, optimistic, and a little bit tart.

Orange and burnished brown appear again and again throughout my garden. Tawny blossoms and foliage rub elbows with a collection of rusty metal chains casually placed among planting beds—a quirky (and affordable) garden accessory that echoes my love of earth hues.

Lend a little zest to your landscape with the tissue paper blossoms of 'Totally Tangerine', which blooms for months on end with precious little input from the gardener. The stems make a good cut flower, although individual blossoms are short lived, shedding their delicate petals with carefree abandon.

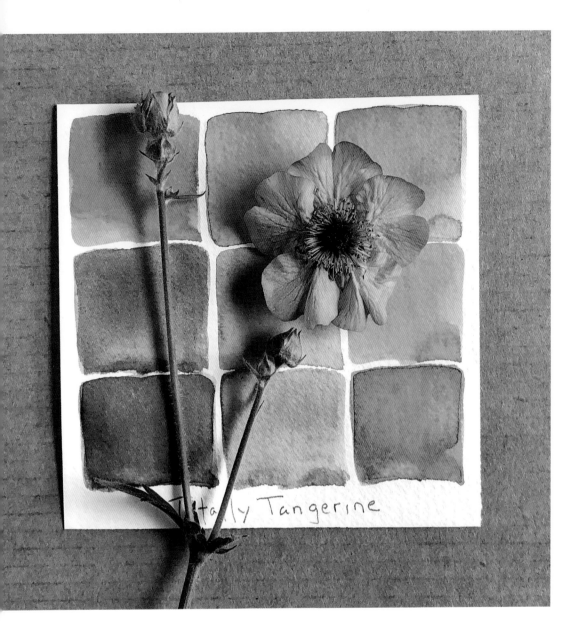

Totally Tangerine' avens
(*Geum coccineum* 'Totally
Tangerine')

Perennial,
24 to 30 inches (61 to 76 cm),
full sun, zones 4–10

tangerine
mango
orange
rust
bronze
kelp

Orange

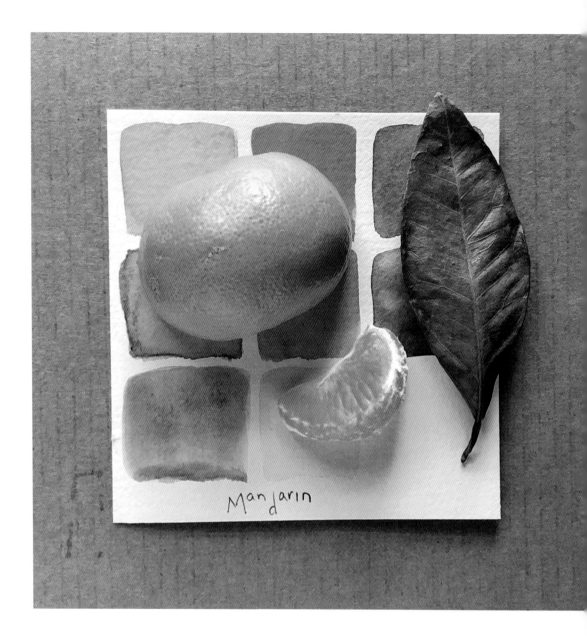

Mandarin

Mandarin orange
(Citrus reticulata)

Woody shrub,
10 to 15 feet (3 to 4.5 m),
full sun, zones 9–11

tangerine
copper
orange
marmalade
emerald
moss

Vitamin See

Let's be honest, sometimes a daily practice is a forced march. **Attention and energy lift and flag.** Thank goodness for citrus in winter.

Grocery shelves piled high with oranges, lemons, limes, tangerines, and grapefruit offer us the chance to swallow the sun even when the days are so very dark. The next time you're feeling diminished, try this exercise to smack some sense back into your dulled faculties.

Cup an orange in the palm of your hand and feel its pleasing heft. Inhale the bracing aroma of bitter oils that spray from the rind as you cut the fruit into sections. Now close your eyes and suck the bright pulpy juices until you feel the crown of your head lighten.

Better?

Citrus Salt

What do you get when you combine an edible rock with the essence of the sun? A seasonal salt that brightens everything it finishes.

*1 tablespoon fresh citrus
 zest*
½ cup (145 g) flaky sea salt

Scrub citrus to remove any wax and dry thoroughly before zesting.

Combine the zest and salt in a bowl, and using your fingers, massage to release aromatic oils. The salt will take on the color of whatever zest you are using—orange, lemon yellow, lime green! Continue massaging mixture until salt is uniformly colored.

Spread the mixture evenly on a small baking sheet and leave to dry overnight on the kitchen counter. If the weather is particularly damp, dry the salt in an oven at 200° F (90° C), until both salt and zest are crumbly, about 45 minutes.

Use your imagination: Finish fresh greens, steamed asparagus, citrus salad with avocado. My favorite winter breakfast is homemade granola topped with runny plain yogurt and a sprinkle of citrus salt. Store citrus salt in an airtight container and use within a couple of months, after which time the flavor will begin to fade.

Tip: Choose firm organic fruit for the best flavor. In addition to orange zest, experiment with the zest of a Meyer lemon, lime, grapefruit, or tangerine.

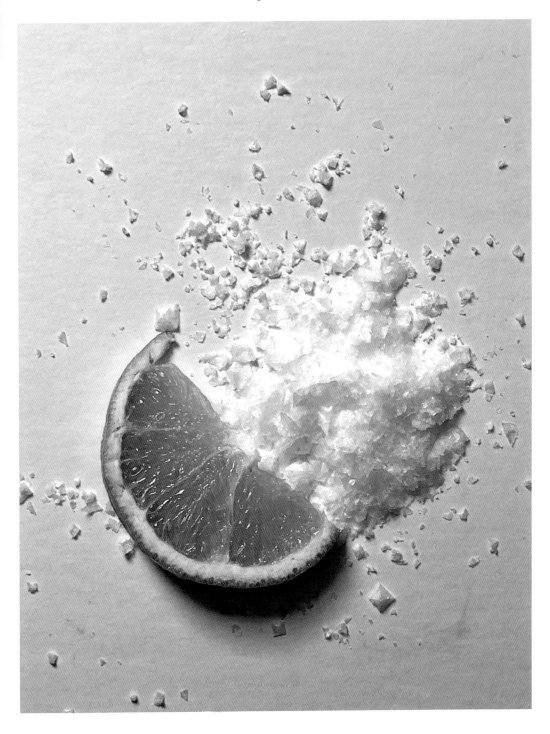

Begonia: A Love Story

Seduced by the promise of orange flowers, I picked up a weary pot of *Begonia sutherlandii* from a nursery sale table in late summer. A species of begonia nearly unknown in the trade, the plant had few leaves and even less promise.

Surprisingly, the tiny begonia was with me for years. Until it wasn't. Who knows what tipped my plant—now grown into a sizable clump—into the abyss? An Arctic blast. A wet winter. Neglect. But once it was gone, I missed it. For years, I scanned plant sales and nurseries, looking for my darling's lime-green foliage, fleshy ruby stems, and tumbling mass of simple blossoms.

Long story short—how other people's love lives do drag on!—I finally found another small plant. This time, I value and tend to my treasure. **One of the gifts of garden making is the possibility of joy and discovery, or rediscovery. Maybe especially rediscovery.**

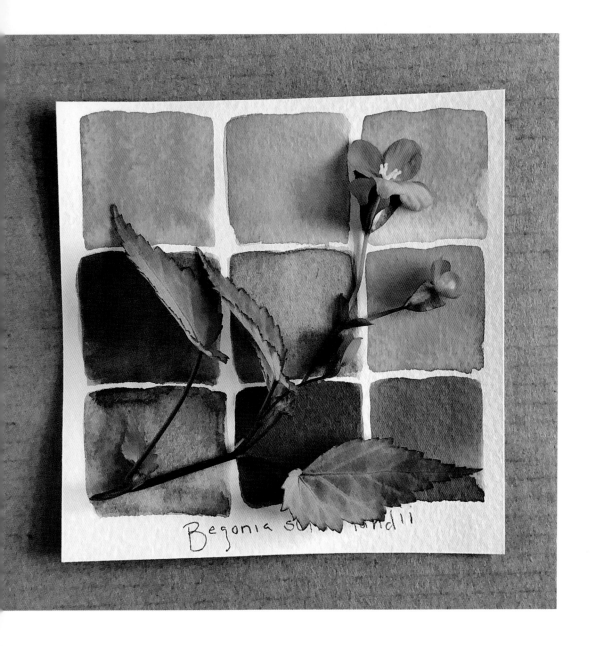

Begonia sutherlandii

Sutherland begonia
(*Begonia sutherlandii*)

Tuberous perennial,
10 to 15 inches (25 to 38 cm),
partial shade, zone 6b

apricot
salmon
orange
merlot
olive
jade

Orange

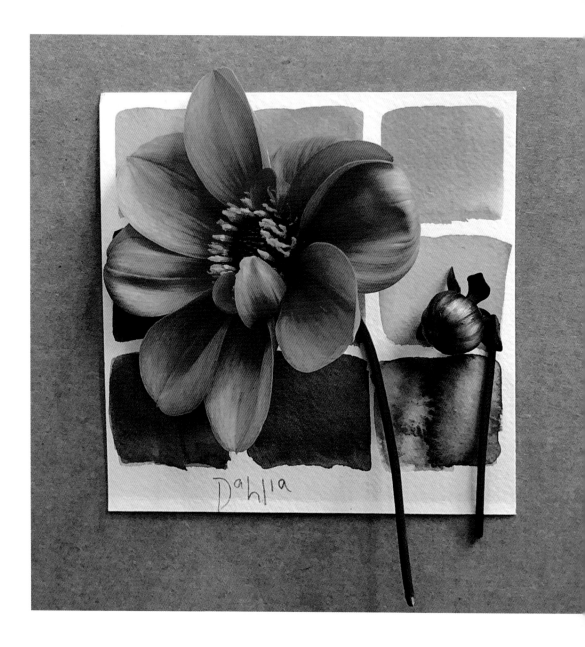

Dahlia

Dark-leaved dahlia
(*Dahlia* spp.)

Tuberous perennial,
3 to 4 feet (.9 to 1.2 m),
full sun, zones 8–11

flame
saffron
rust
bronze
chocolate
forest

Pumpkin Spice Dahlias

Every autumn, fields of chubby round pumpkins appear among tangled vines and enormous leaves powdered with mildew. The robust weight of the harvest—the literal mass where once there was only a small flat seed—feels like magic.

At home, dark-leaved dahlias kindled in flaming hues carry the summer garden over the finish line, generously producing stems for bouquets until first frost. Burnt-orange blossoms and round button buds where once there was just a gnarled tuber. More magic.

It doesn't get old, and I hope it never does.

Brown Flowers

I have a thing for brown flowers. While an entire garden planted in earth tones might be a bit drab, bronze blossoms and amber foliage provide welcome warmth and contrast in a predominantly green landscape. And perhaps these more tarnished tones are less of an affront to delicate tempers than true orange, brown's loud, sometimes bratty little sister.

I've been growing this burnished tea-colored Barnhaven primrose from the 'Spice Shades' seed strain for more years than I can remember. I never tire of its dignified brow.

Hardy perennials, my plants gladly suffer transplanting, division, drought, and cutworm assault. Every year, gardening in my head, I vow to multiply their numbers to plant among the grassy foliage of copper sedge and the bronze crosiers of emerging tassel ferns to create a pleasing repetition of colors. I must say, I get a lot done in those planting daydreams.

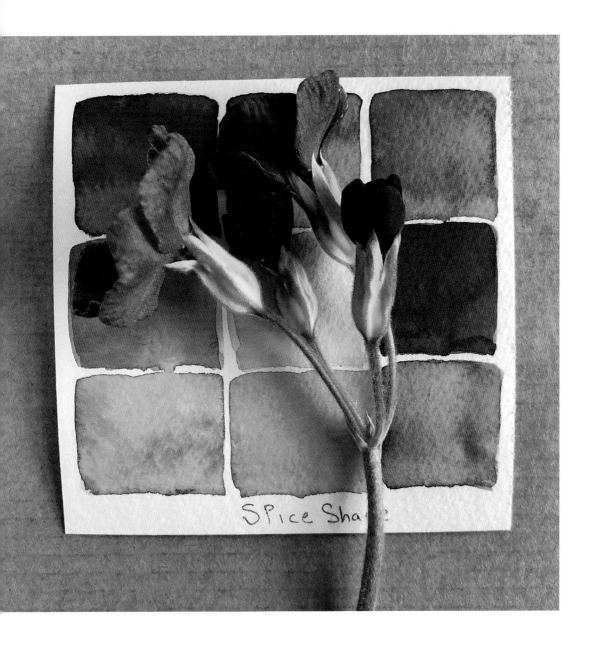

Spice Shades

arnhaven primrose
'Spice Shades'
Primula polyanthus
'Barnhaven Spice
Shades')

Perennial,
6 to 8 inches (15 to 20 cm),
partial to full shade, zones 4–8

strong tea
maple
rust
caramel
jade
copper

Orange

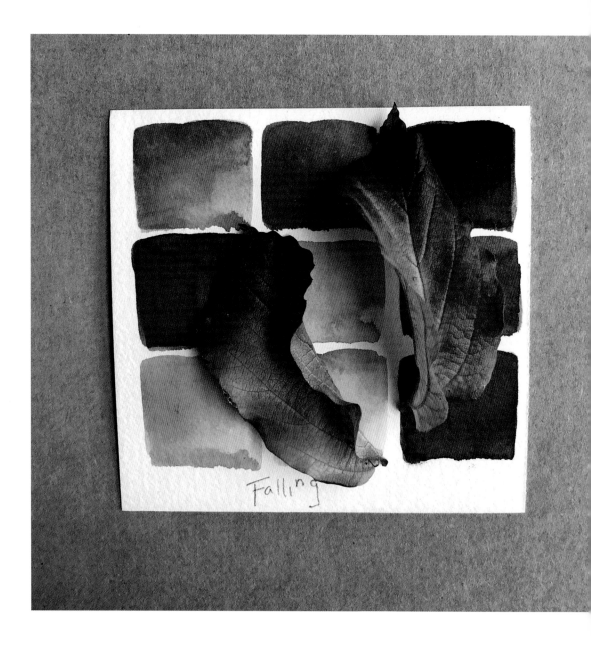

Falling

Persian ironwood
(*Parrotia persica*
 'Vanessa')

Columnar tree,
slowly to 40 feet (12 m),
full sun to part shade, zones 4–8

amber
merlot
burgundy
caramel
umber
copper

Letting Go

Decline is the flip side of gardening's cheer.

Yet **being a gardener teaches a wide-angle perspective**. In the garden this is life after death, beauty in decay, and the assurance of one season following another. The elegance and inevitability of these transitions is guided by a wisdom that far exceeds understanding.

Raking leaves, cutting back frost-blackened dahlias, or cleaning up the season's last bouquet of faded blooms on the kitchen counter is a constant education in navigating loss.

They may not be comfortable, but these garden lessons are instructive. Fall is a good time to shed the unnecessary.

Brown

Chalky bluffs, flaxen dust, and pale sand luminously reflect light, but are in fact barren and vacant. These stylishly acceptable shades may suit a tasteful interior, but their shallow and sterile nature is too thin to support vitality out in the natural world.

Growth relies on substance and depth. If you want to feed the world, furnish the hills, and flourish, choose complexity and vigor over wan good looks and a lean figure. Gritty soil, sticky muck, and mineral oxides yield expectantly fertile sweet loam and chocolate soil.

About town and deep in the country, grounding every city, field, and forest. The foundation of all living things: gardeners appreciate dirt brown.

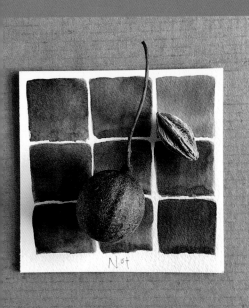

Nut

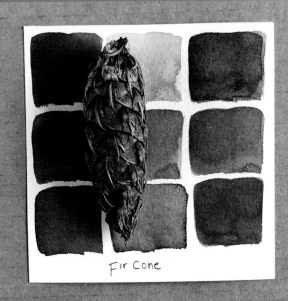

Fir Cone

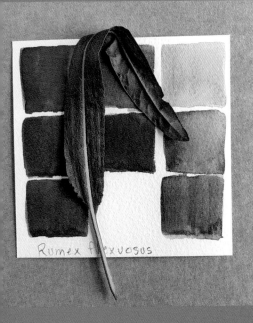

Rumex flexuosus

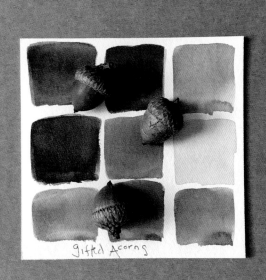

gifted Acorns

Chapter 4

Yellow

Ochre Straw Sunshine Primrose
Champagne Honey Dandelion Lemon
Banana Wheat Daffodil Moonlight
Buff Goldenrod Citrine Canary

Leveraging Light

When we look at a landscape, luminosity—actual daylight—determines how we see color in the garden. In the thin light of spring, a creamy yellow tulip appears radiant, yet chrome-yellow forsythia, while an ebullient end to winter, can seem a bit brash among pastel blooms. A few months later, brilliant school-bus-yellow sunflowers and golden black-eyed daisies hold up under the strong overhead light of summer, in company with the saturated hues of zinnias, dahlias, and craning stems of fiery montbretia.

Yellow is the brightest color on the spectrum. And in nature, where the color is common, yellow plants and blossoms are the most visible, even in low light. As gardeners, we can place plants to harness the time of day and leverage light to spectacular effect—for instance, by using lemony flowers and golden foliage to illuminate shady corners. Dreamy pastel-yellow blooms bring sunshine to a gray day, but—like forsythia in spring—blinding yellow requires strong-colored cohorts.

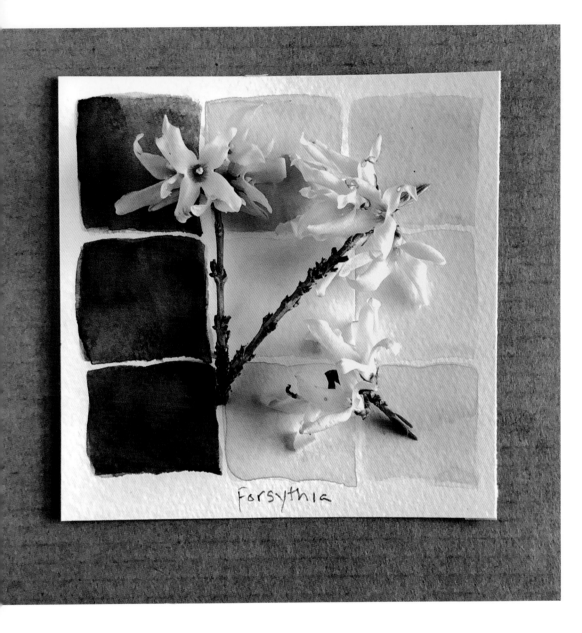

forsythia

Forsythia
(*Forsythia* × *intermedia*)

Woody shrub,
3 to 10 feet (.9 to 3 m),
full sun to part shade, zones 5–8

school bus
goldenrod
chrome yellow
sunshine
acorn brown
umber

Yellow

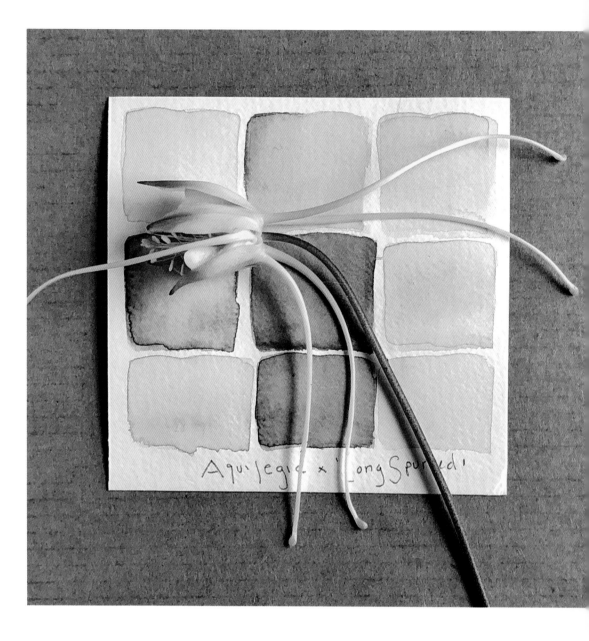

Spurred columbine
(*Aquilegia longissima*
 'Long Spurred')

Perennial,
14 inches (35 cm),
sun to part shade, zone 4

honey
goldenrod
canary
sunshine
kelp
umber

Flight of Fancy

We are never alone in our gardens. In spring, nectar-rich blossoms and new growth inevitably attract pests. The next time this happens, before you reach for an organic control or blast infestations with a strong spray from the hose, pause to consider: no bugs, no baby birds. What appears at first glance to be aphids on the roses is in fact a veritable buffet of sugars and protein perfectly timed for nesting season. Fluttering wings and trilling avian courtship calls are your reward for adopting a conservative approach.

Nature is a dynamic dance among plants, animals, birds, and insects—and we're all a part of that wild mix. I think this extraordinary North American native columbine looks like a gold finch in very fancy dress.

In the Weeds

There's an old garden adage: One year of seeds equals seven years of weeds.

Sometimes described as "anything growing in the wrong place," weeds are in fact a group of plants that have developed amazing reproductive capabilities and tough constitutions that allow them to survive where other, more "civilized" plants cannot. In this way, weeds play a valuable environmental role in covering bare ground and preventing erosion. But, as another saying goes, NIMBY (Not In My Backyard).

Here's an idea. What if we weed out the intruders but adopt their resilience, persistence, and constancy? Dependably prompt and, certainly in the case of dandelions, anchored deep into the soil.

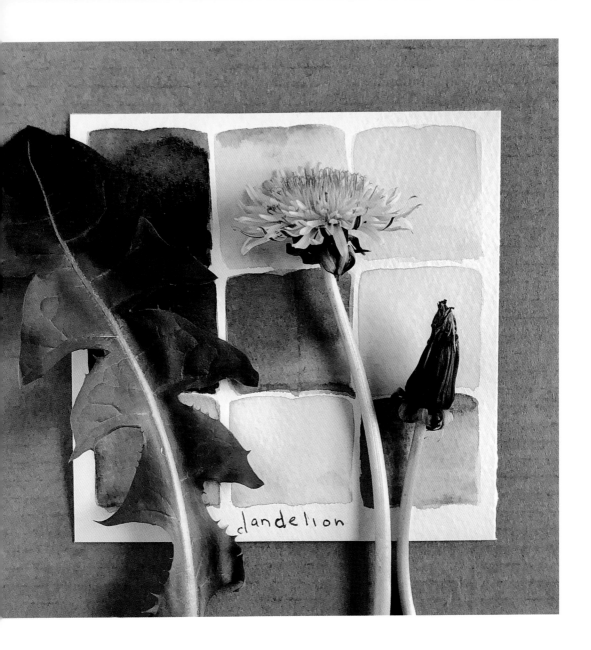

dandelion

Dandelion
(*Taraxacum officinale*)

Perennial herb,
3 to 10 inches (8 to 25 cm),
full sun to shade, zones 3–9

sunshine
goldenrod
canary
celadon
jade
emerald

Yellow

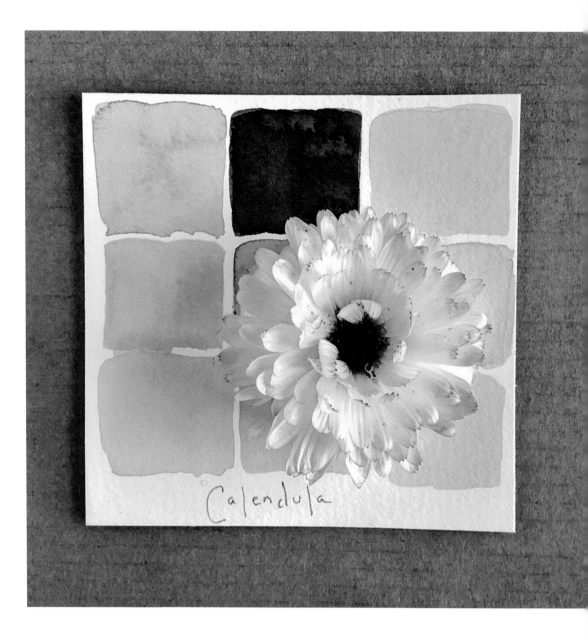

Calendula

Calendula
(Calendula officinalis)

Annual,
1 to 2 feet (.3 to .6 m),
full sun, zones 2–11

buttercream
vanilla
canary
coral
burgundy
ivory

Every Day

Once you begin a daily color practice, you may find you look at the world more expansively. In the garden, you will begin to notice details in every part of a plant—its stem, bark, petals, and seed heads. When you look closely, you'll see that the nuance of nature is marvelous. And every day is different.

Calendula gets its name from the same Latin word that gave us "calends" (which became "calendar")—that is to say, from the plant's propensity to bloom, in mild climates, in every month of the year. My plants don't quite achieve that marker, but I enjoy their extended flowering and encourage them to seed about my beds.

This little lovely reminds me of one of those fancy chickens with fluffy feathers. Which is about as close as I'll ever get to keeping hens. But oh, how I'd love the fresh eggs.

A Gardener's Bestie

Calendula, sometimes called pot marigold, is dependable and low-maintenance, and has a sunny disposition. I highly recommend inviting it into your garden mix for its many supportive properties.

Long months of nearly constant bloom provide pollen and nectar for butterflies, bees, and beneficial insects, which in turn boost pollination and help control garden pests. But that's only the beginning for this hardworking herb.

Fresh petals have a pleasingly spicy, slightly bitter taste. Liberally garnish green salads with them or add them to herb butters or soft cheese for a pop of color. When preparing rice, you can add fresh or dried calendula petals, traditionally referred to as a "poor man's saffron," for a nice golden hue.

Use fresh or dried calendula to brew an herbal digestive tea; serve hot with a touch of honey, or cool and serve over ice. Applied externally, calendula tea can be used as a soothing facial toner.

Calendula oil is an antifungal, antibacterial, and anti-inflammatory treatment for minor cuts and abrasions. Place 5 or 6 dried flower heads, or about 1 cup (1 ounce) of loose dried petals, in an 8-ounce (240-ml) jar and pour in enough oil—a mild olive or almond oil will do nicely—to completely submerge the flowers. Steep the mixture on a sunny windowsill to infuse the carrier oil with the nourishing properties of the plant. After at least 3 weeks, or as long as several months, strain the oil to remove flowers and pour into a clean dry jar.

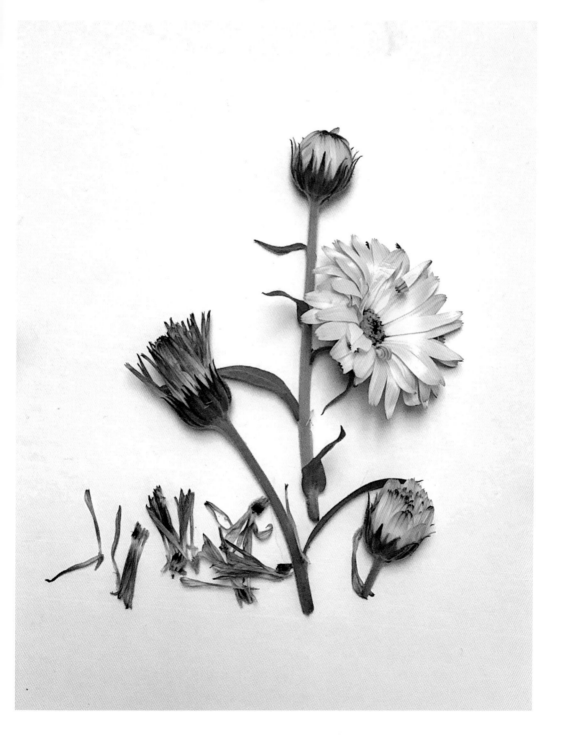

Chill

Chamomile blossoms are nature's remedy for stress and sleeplessness.

In the garden, there are two types of chamomile. Both have tiny white daisy flowers and smell like green apples and fresh hay, but the plants have very different growing habits. Roman chamomile (*Chamaemelum nobile*) is a mat-forming perennial that spreads by rhizomes and forms an aromatic ground cover that can take light foot traffic; it inspires dreams of lolling about on a chamomile lawn while robed in white linen, nibbling strawberries.

German chamomile, by comparison, is a bit of a gawky wildling. A shallow-rooted annual given to sowing itself about the garden, German chamomile is a good companion plant in the vegetable garden, with tall slender stems producing scores of easy-to-harvest blossoms throughout summer. Both the finely textured foliage and the flowers are fragrant, and can be used fresh or dried. Infuse them in water to brew a naturally sweet tea, or steep them in warm milk with a touch of honey for an especially soothing nightcap.

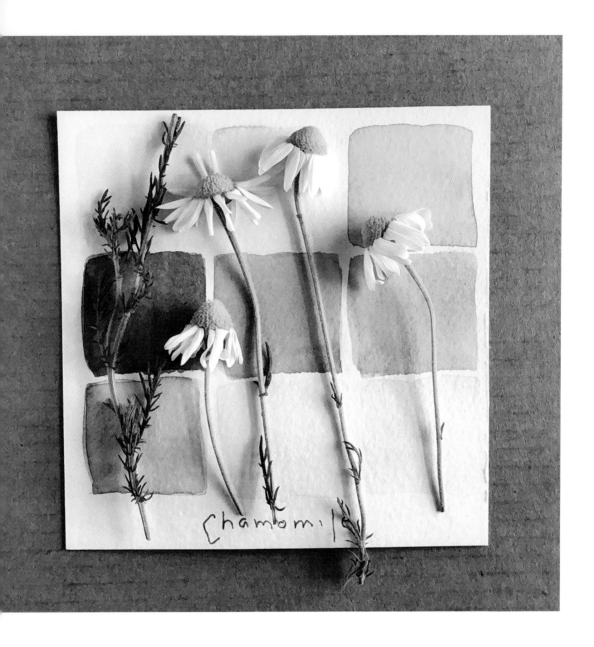

German chamomile
(*Matricaria chamomilla*)

Annual,
18 to 24 inches (46 to 61 cm),
full sun (provide partial shade in
warmer growing regions),
zones 2–9

ivory
vanilla
linen
goldenrod
grass green
hay

85

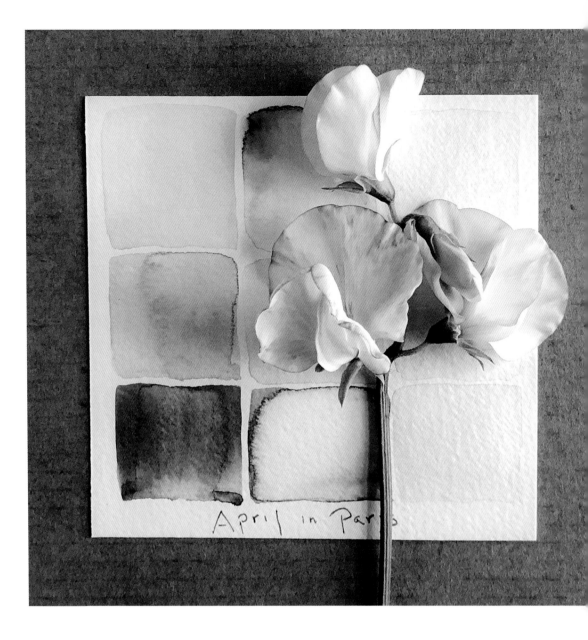

'April in Paris' sweet pea
(*Lathyrus odoratus*)

Annual vine,
6 to 8 feet (1.8 to 2.5 m),
full sun, zones 2–11

cream
primrose
ivory
heliotrope
grass green
violet

The Scent of Memory

I wait all year for the day when I can harvest the first sweet peas of the summer.

The delicate flowers are a personal totem and a generational touchstone in my life. Impossible to accurately replicate, the scent of sweet peas—part honey, part orange blossom—holds the memory of every blossom from the time I was a child in Nana's garden to those of nearly every year since. Follow your nose through a garden and pay attention to what memories are triggered: freshly cut grass, lazy summer days and lavender, honeysuckle evenings. We can plant to preserve the past.

In addition to being intoxicatingly fragrant, as I believe all sweet peas should be, this variety is notable for its large, ruffled blooms in a novel primrose-yellow hue outlined by violet that deepens as each blossom matures—a perfect display of complementary colors that holds my attention and makes me swoon.

Quotidian

Once it begins blooming, the evening primrose produces a flush of languorous lemon-yellow blossoms every afternoon. The generous blooms on the lanky, frankly rather unkempt, sprawling plants exude a delicious fragrance at dusk, then, setting with the sun, they turn shades of apricot and rose before wilting.

The display goes on day after day, and the one after that. Tough, resilient, and independent, or fragile and fleeting—it's all in your perspective. Quotidian: belonging to each day.

"Quotidian" can also mean "commonplace" or "ordinary." There are plenty of tedious recurring garden rhythms—we all have our list; winding up and putting away hoses tops mine, followed closely by tripping over hoses left out.

But, for the most part, I find the garden to be anything but ordinary. **The more I look, the more wonder I see.** Except hoses; those remain as banal as you-know-what.

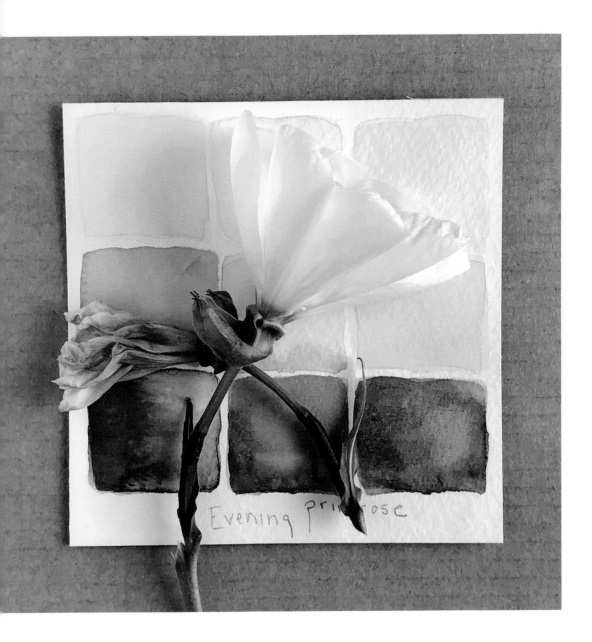

Evening primrose
(*Oenothera odorata*)

Perennial,
a lax 2 to 3 feet (.6 to .9 m),
full sun to part shade, zones 4–8

lemon
primrose
buttercream
apricot
wine
bronze

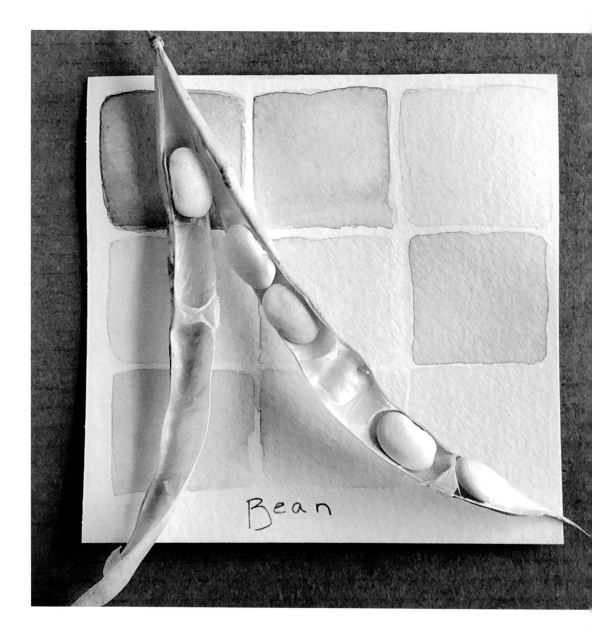

'Sorana' pole bean
(*Phaseolus vulgaris*)

Annual vine,
6 to 7 feet (1.8 to 2.1 m),
full sun, zones 2–11

ivory
cream
oyster
straw
linen
buff

Germinate

Clutching seedlings in paper cups in an overheated classroom, we knew we were onto something wonderful. Something bigger than we could grasp. Wonder comes easily to children and gardeners.

A seed is living history. A time capsule of every growing season that came before this one. It is also a bridge from here to there, from right this minute to all that comes next.

Cultivated attentively, a seed is simultaneously a love letter and a field guide to place, a record of global maneuverings, and a biography of passion, or maybe just infatuation.

From one year to the next. This is what continuity looks like. 'Sorana' pole beans are an Italian heirloom that have been grown for centuries: carefully tended, seeds saved, a piece of time. Plant beans, recover wonder. You might discover a pot of gold; for sure you'll end up with a pot of delicious beans.

The Consolation of Conifers

Love and loss, beauty and decline, holding tight and letting go. Keats was right, there's a holiness to our hearts' affections.

I planted this tidy dwarf conifer in memory of my dad. Right around the same time, I began capturing and recording the colors in my garden. I was grieving and needed something simple to do every day, day after day, something that might help carry me through the hard parts, provide focus, quiet the noise, and begin to heal this daughter's heart.

Dad spent his career as an engineer in the space industry—Rocket Man, my brothers and I called him, teasing. Every time I see this steady, gold-tipped rocket-shaped evergreen, pointed toward the heavens in my front garden, I think of him.

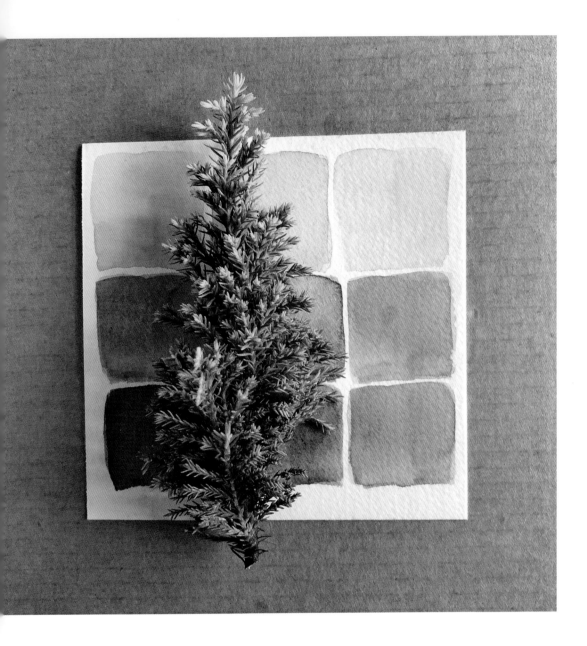

Golden Lawson cypress
(*Chamaecyparis lawsoni-
ana* 'Treasure Island')

Evergreen conifer,
4 feet (1.2 m),
full sun to part shade, zones 5–9

marigold
celadon
jade
peridot
forest
burnt umber

Yellow

Gold

What a garden does in one year takes the rest of us a lifetime to accomplish.

Long days of faithful—OK, sometimes not-so-faithful—tending, punctuated by fugitive moments of germination, bud, and bloom, are how gardeners mark the passage of time. Every year is new, but traces of the old remain, a palimpsest of past blooms, berries, and beans.

Maybe because I was an October baby, I am especially attuned to the shift into fall, a season of both fruition and depletion. Ample moisture and forgiving temperatures refresh parched plantings. Autumn is both a temporary reprise of spring and a threshold to dormancy.

The sun drops on the horizon, burnishing fall foliage and illuminating petals and seed heads with a flattering side light. An angle that my aging self has come to treasure. Even the funk of wet autumn leaves, a sweet stink of decay that's one part burnt sugar, one part moldering damp towel, lends depth to the glow.

To the non-gardener, and maybe for those uncomfortable with watching a garden age, the fall season can appear a bit shopworn and tired. But for those who look closely, abundance and generosity are everywhere. This is the time of ripening pods and seed harvesting—the foundation of next year's garden, when everything begins again.

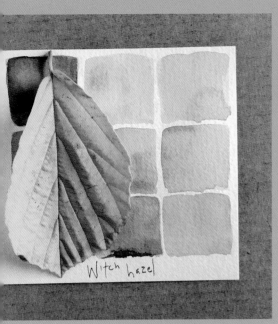

Witch Hazel

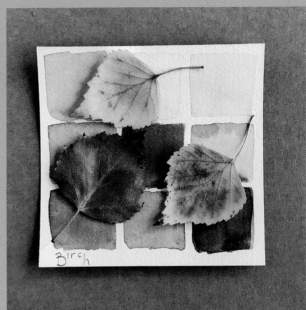

Birch

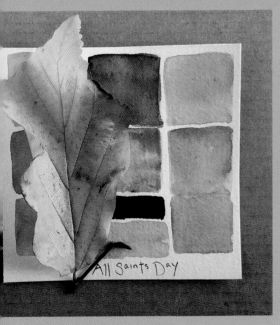

All Saints Day

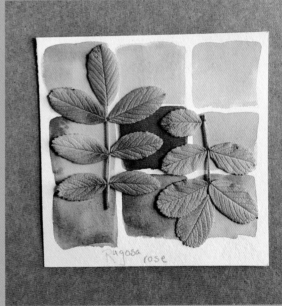

Rugosa rose

Green

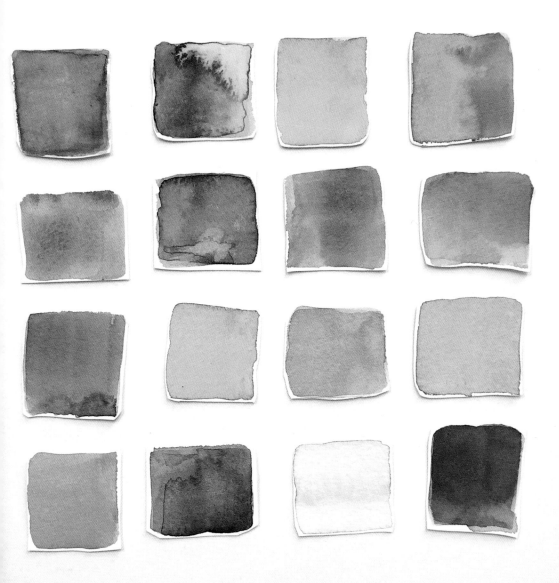

Avocado	Sap green	Jade	Verdigris
Sage	Emerald	Fir	Lawn
Moss	Lime	Pistachio	Celedon
Olive	Fern	Celery	Ivy

Growth

Green can't help itself. It is the most powerful color in a landscape. From the start of our collective human history, a verdant environment filled with plants and tall grasses was a sign of hospitable, nourishing conditions. Maybe that's why we **humans can distinguish more shades of green than of any other color on the spectrum.**

Our very lives once hinged on green.

Yet, in the garden, green is so ubiquitous that it is seemingly invisible, hidden in plain sight. Faced with a purely green landscape, most gardeners yearn for "a spot of color" to leaven the sameness of all that potent fertility.

Green is more than a color; it is the photosynthetic driver that powers our existence, feeding our bodies and filling our lungs with breath.

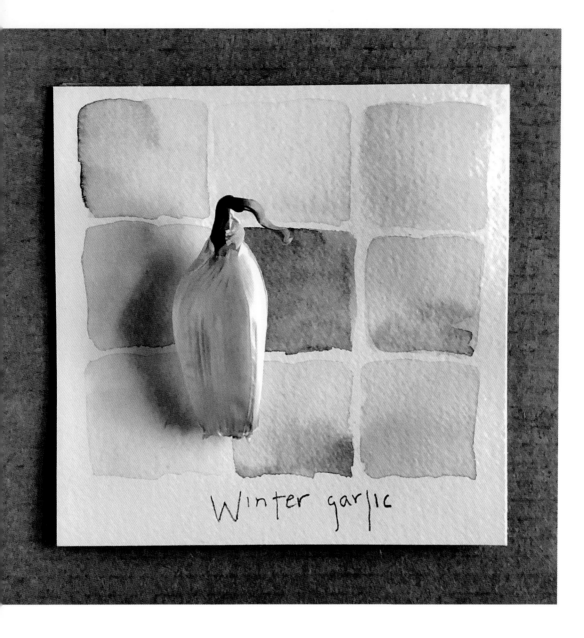

Winter garlic

arlic	Bulb,	parchment
(Allium sativum)	1 to 2 feet (.3 to .6 m),	ivory
	full sun, zones 3–8	buff
		rose
		peach
		grass green

Green

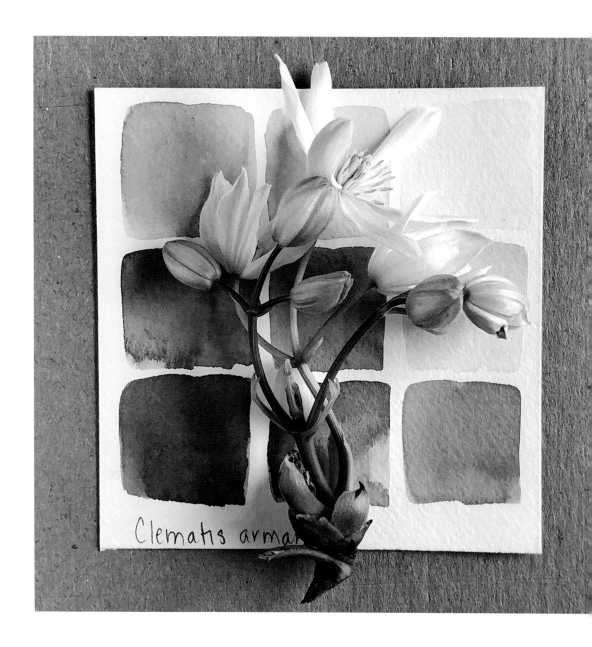

Clematis arma

Evergreen clematis
(Clematis armandii)

Woody vine, quickly to 20 feet
(6 m), full sun to part shade,
zones 6–9

emerald
lime
pistachio
grass green
rose
ivory

Becoming

A wise friend of mine once said we become our best selves in the garden.

Caring for a garden connects us with rhythms that govern the seasons, pull the tides, and turn dark into light. It tethers us to others, friends and strangers alike, who tend their plots with equal fervor. People with their hands in the soil speak in a common tongue that is both exalted and humble.

My garden teaches me to tend, to nurture, and to watch for both incremental change and overnight transformation, like the speed with which the burly evergreen clematis goes from fragrant blooms to swamping the front steps with its ranging tendrils.

Our gardens tolerate our inclination to organize and orchestrate plant performances, though, more often than not, a court jester shows up in the form of an errant red anemone, a tenacious weed, or an annoying but faithful tunneling mole to deflate any seriousness and encourage us to loosen our grip. But go ahead and trim the evergreen clematis, or risk that somebody's going to trip.

May Wine

Sweet woodruff is a rambling ground cover that colonizes shady nooks in the garden, forming a companionable carpet beneath other plants. It is a pleasing but unremarkable herb. Except for a moment in spring when its tender stems, stacked with whorls of green leaves, are topped by constellations of starry white blossoms. Then it is exquisite.

In the garden or when freshly picked, sweet woodruff has little scent. But as the plant wilts, it releases an aroma of vanilla and straw—sweet with an earthy undertone. Fragrance may be unseen, but it is one of the garden's most potent elements. An indelible imprint of the season.

Infuse the foliage and blooms of sweet woodruff in white wine to brew a traditional German beverage served on May Day in a celebration of spring; the wine was quaffed during maypole dances, which were originally fertility rituals. You're not likely to find this unsung character packaged in a plastic clamshell alongside other herbs at the market. Which means May wine is a treat reserved for gardeners and their friends in spring.

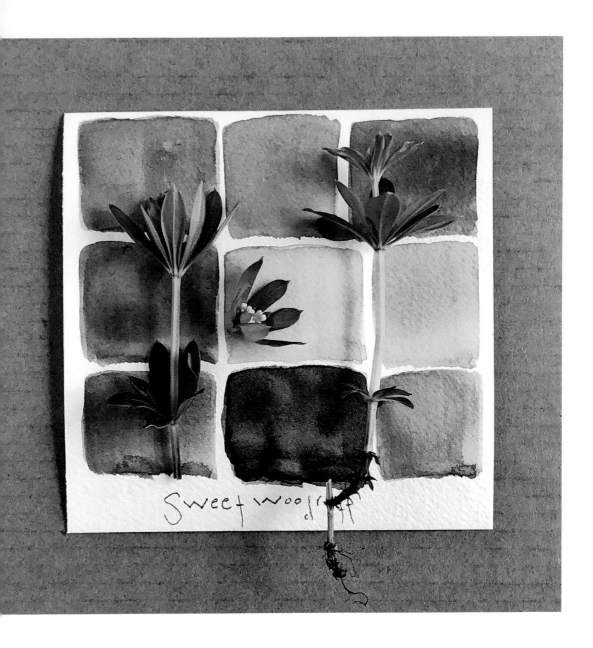

Sweet woodruff
(*Galium odoratum*)

Perennial herb,
8 to 12 inches (20 to 30 cm),
partial to full shade, zones 5–9

fern
emerald
jade
celadon
moss
chocolate

Green

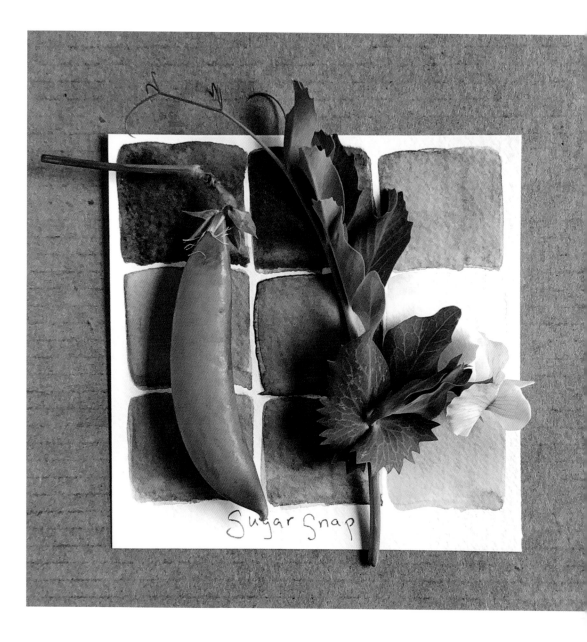

Sugar Snap

Peas
(*Pisum sativum*)

Annual vine,
4 to 6 feet (1.2 to 1.8 m),
full sun to part shade, zones 2–9

fern
pistachio
grass green
celery
forest
moss

Perfect Timing

Garden peas harvested at just the right moment and devoured within minutes of picking are as sweet as a cold glass of water on a hot summer day. Leave the peas too long on the vines, and plant sugars turn disappointingly starchy. Whether you choose to grow traditional plump shelling peas or juicy eat-the-whole-thing sugar snap varieties, pay close attention to capture this exquisite, and fleeting, seasonal flavor.

Peas flourish in cool weather, making them one of the earliest spring crops you can plant out in the garden. Gardeners in the warmest growing regions can sow seed in the fall to overwinter and harvest in early spring. The rest of us can thickly sow leftover pea seed in late summer or early fall to produce a flavorful crop of tender greens that can be added to fresh salads or quickly sautéed in butter with a touch of mint.

Again and Again

The mint is flourishing in the garden, filling pots and running roughshod through the campanula, just like it did last year, and the one before that. Crushing a stem between your fingers and cupping it to your face, inhale its cleansing coolness.

As time flies or never ends or repeats incessantly; breath is how we accumulate our days. Life is sometimes painful, sometimes giddy; it is tedious and remarkable in equal measure. Mixing and matching subtle colors is satisfying, and with practice comes fluency. Look closely to discern a variety of hues, like the celery-green highlights and the deep purple flush in this stem of chocolate mint. There are no mistakes, only occasions to improve. Thankfully, there's tomorrow and the day after, and the one after that.

And again and again.

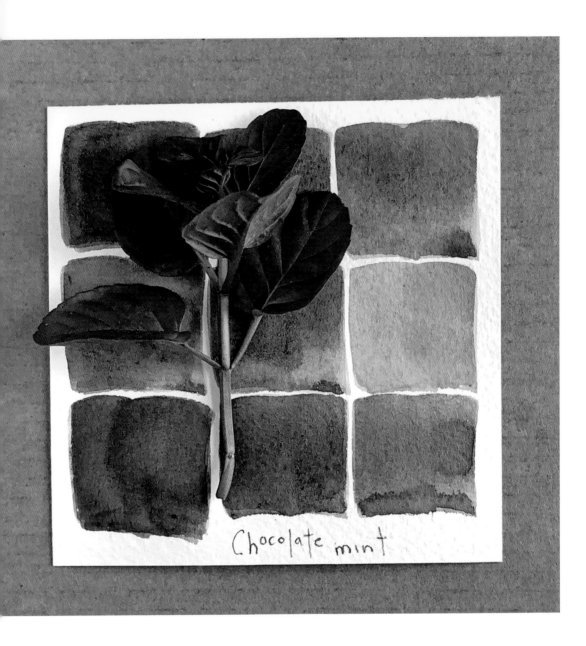

Chocolate mint

Chocolate mint
(*Mentha × piperita*
'Chocolate')

Perennial,
18 to 24 inches (46 to 61 cm),
full sun to part shade, zones 3–11

emerald
moss
mint
ivy
forest
plum

Green

Mint Hints

Mint is a vigorous spreader that makes its way through garden beds by means of shallow-rooted runners that can quickly and irretrievably infiltrate clumping perennials.

Cultivating mint in containers helps curb growth—and saves having to chase down errant runners, a tedious if deliciously fragrant chore. That said, in addition to growing a number of mints in containers, I grow spearmint in a narrow shady bed where it peacefully coexists with an equally vigorous ground-cover campanula in a tangled display of fresh green leaves and starry lavender-blue flowers. Stray mint runners that do make their way into the adjacent gravel pathway are trod into submission, wafting a bracing welcome to visitors as they enter the back garden.

In addition to their familiar cooling quality, various mints have different fragrances and flavor profiles. Peppermint has a peppery scent and sharp taste, while spearmint is softer and sweeter. Chocolate mint, with dark green leaves flushed with a burnished cocoa color, really does smell a bit like chocolate. Lemon mint, apple mint, ginger mint, and pineapple mint are just a few of the many mints available to home growers.

Handle mint carefully when harvesting. Like basil, which is also in the vast mint family of plants, most mints bruise easily, which leads to oxidation and bitterness. To brew a naturally sweet infusion without a trace of bitterness, use the refrigerator instead of a teapot.

Lightly "clap" and roll 3 or 4 stems of fresh mint between your palms to gently release aromatic compounds. Place leaves and stems in a 1-quart (960-ml) jar of cool water and cover. Steep mixture in the refrigerator for 24 to 48 hours, depending on how strong you'd like your finished infusion to be. In as little as 3 to 4 hours, you'll have a refreshing flavored water, delicious on a hot day garnished with a spear of cooling cucumber. A longer steep produces a stronger tummy-soothing brew that aids digestion. Stronger infusions may also be used as a tonic scalp rinse or a cooling facial mist. Store infusion in the refrigerator and use within one week.

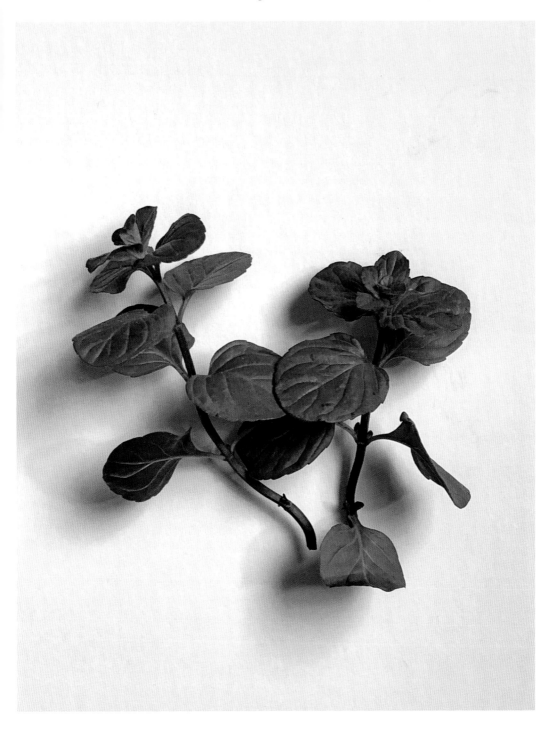

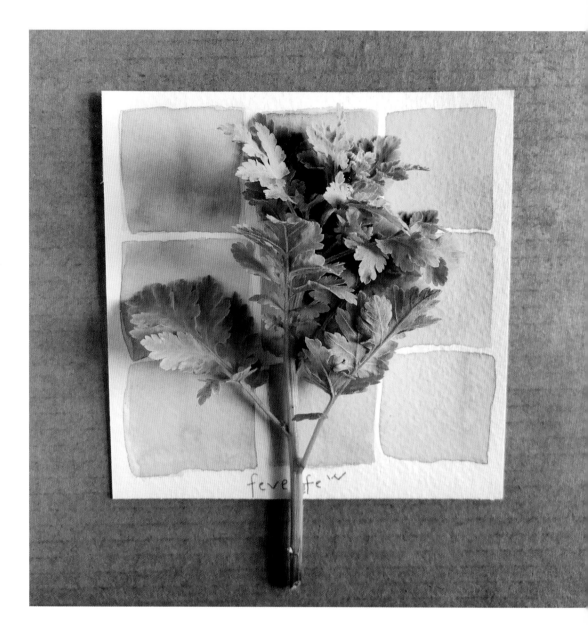

feverfew

Golden feverfew
(Tanacetum parthenium 'Aureum*')*

Perennial herb,
8 to 12 inches (20 to 31 cm),
full sun to part shade, zones 5–8

chartreuse
citrine
lime
olive
celadon
celery

Bitter Herbs

Our ability to detect bitterness is thought to have evolved as a way to protect us from ingesting toxic plants. **Bitter gets our attention** and in small doses can heighten our senses, adding depth and dimension to flat, easy-to-swallow flavors.

The chartreuse foliage of golden feverfew pierces the garden like a shaft of sunlight. An unfussy, short-lived perennial that politely seeds about, feverfew may be left to insinuate itself in borders wherever it pleases. Harvest the foliage and small white daisies with yellow button centers—sweet chamomile's more complicated twin—for windowsill herbal posies or to brew a pleasantly bitter concoction that's said to relieve fever and reduce inflammation. Some people find relief from migraine headaches by chewing a small leaf of feverfew on a regular basis.

When mixing your paints for this color study, rely on clear cool yellow with a touch of blue to capture the plant's sunny disposition.

Coastal Fantasy

Most gardeners have a rich interior life and a vivid imagination.

My near-but-not-on-the-water garden is a fanciful stage set for coastal vibes. Twisted trunks of Hollywood juniper seemingly record maritime gales—only without the harsh wind or waterfront property taxes. Animated branches with lustrous evergreen foliage look like they're conducting waves of seasonal bloom and flowing grasses.

While growing this conifer is nearly effortless, capturing its colors with paint on paper proved challenging. Simply mixing yellow and blue yields a dubious green of the sort most often found on landscaping accessories. But adding to the mix a touch of rusty red or cinnamon brown, like that of the juniper's shaggy bark itself, shifts the artificial plastic hue to a more believable color. When trying to match nature's colors, refer to all the colors that are a part of the plant.

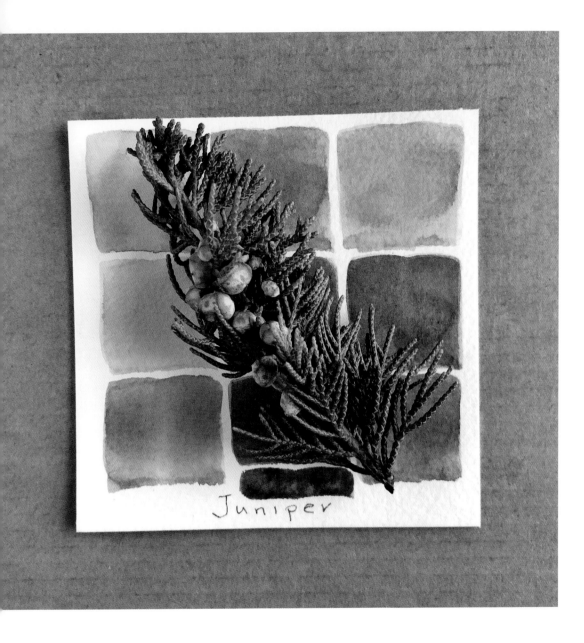

Juniper

Hollywood juniper
Juniperus chinensis
'Torulosa')

Woody conifer,
15 to 20 feet (4.5 to 6 m),
full sun, zones 5–9

emerald
olive
forest
peridot
verdigris
umber

Green

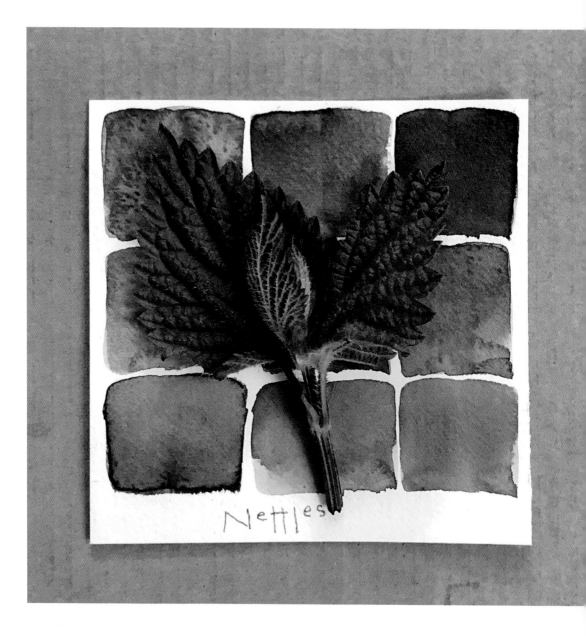

Stinging nettle
(Urtica dioica)

Perennial,
3 to 4 feet (.9 to 1.2 m),
sun to part shade, zones 3–10

forest
olive
avocado
eggplant
bronze
graphite

Foraging

The damp understory of a nearby wooded greenbelt is carpeted in nettles. Later on in the summer, the plants provide larval food for several types of butterflies and moths, but in early spring I forage in the young foliage for a seasonal treat that's said to be a good tonic for shaking off winter.

Harvest the most tender new growth, snipping with scissors so that the nettle tips fall directly into a brown paper bag. Wear gloves and protective clothing and be careful! Nettles are covered with bristly hairs that act like needles and will pierce any exposed skin that happens to brush against the plant, releasing chemicals that cause a painful (but mostly annoying) rash.

Back home, a one-minute dip in boiling water blanches the greens, while retaining their bright green color and lively mineral-rich flavor. Enjoy the herbaceous flavor of nettle tea throughout the year by bundling fresh plants and hanging them to dry in a warm, dry, and dark location. Once cooked or dried, nettles lose their sting. Find an experienced guide to introduce you to woodland wonders if you are new to foraging.

The Sound of Green

"Green as the sound of an oboe." More than forty years ago, I read a book about an artist, it may have been Paul Gauguin, a Postimpressionist painter who used brilliant color to express observation and memory. The artist's name is lost to me now—the book was an add-on for buying laundry detergent, that I do remember. But that fragment of a sentence has stuck with me ever since.

Years later, when I learned about synesthesia, a neurological condition that results in the melding of the senses, I immediately thought of that line. For a synesthete, sound, color, touch, and flavor are linked in ways not available to the rest of us. For instance, a sound, say the full-throated tone of an oboe, may trigger seeing the color green.

Clipping a stem of lustrous bay, crushing the fragrant leaves in my hand, and infusing its flavor in a rich stew is how I approximate this layered perception.

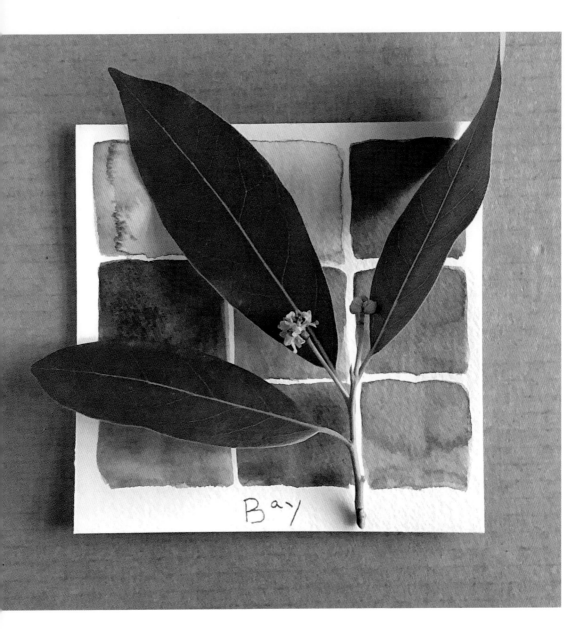

Bay
(*Laurus nobilis*)

Evergreen tree,
10 to 30 feet (3 to 9 m),
sun to part shade, zones 8–10

forest
olive
avocado
eggplant
bronze
graphite

Green

Aqua

Carolus Linnaeus, eighteenth-century Swedish bota-
nist and physician, wrote, "*Omnia mirari etiam tritis-*
sima." Wonder at everything, even the most everyday
things.

When Linnaeus developed principles for classifying
and organizing the natural world, both plants and ani-
mals, he gave us a common vocabulary across all lan-
guages. Binomial nomenclature, a two-part Latin-based
naming convention, is still in use today. Although, to
the everlasting dismay of most nursery professionals,
the system is far from fixed. Modern DNA sequencing
has dramatically altered the science of taxonomy, which
was previously based strictly on observation.

Plants people who use fragments of what many con-
sider a dead language aren't being deliberately obtuse.
We're being specific. A traditional margarita (rocks
with salt, please) is made with lime (*Citrus aurantii-*
folia), not lime (*Tilia cordata*, a tree that's native to
much of Europe). On the other hand, lime blossom tea
brewed from *Tilia* flowers is a soothing caffeine-free
tea. Except that it isn't a tea at all. Only the leaves
of *Camellia sinensis*, a tropical evergreen shrub, may
properly be called tea. But, then, what do we make
of the aromatic Australian native tea tree (*Melaleuca*
alternifolia)? I think I've made my point.

Observation, language, and wonder are portals to
the particular. Slow down, look closely. I know it feels
silly to put your nose up close—I do it every day. And
I see more than I used to. It's not always easy or com-
forting. But paying attention is as close to a super-
power as most of us are ever going to get.

'Langtrees'

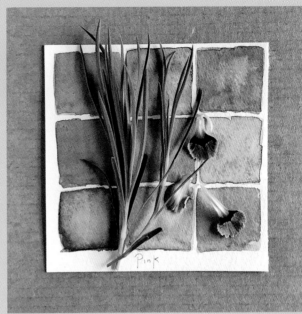

Pink

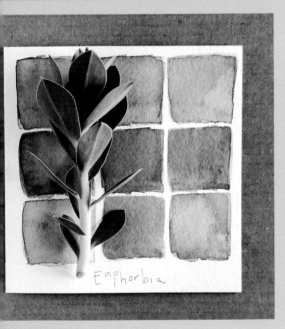

Euphorbia

C marit...

Chapter 6

Blue

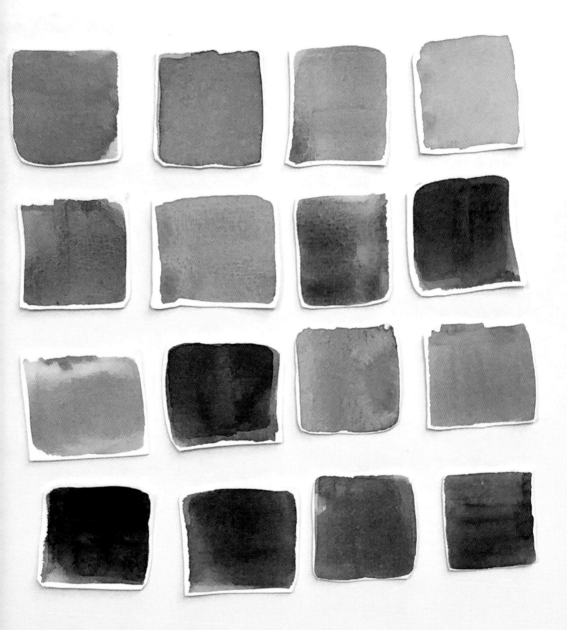

Azure
Borage
Fog
Cobalt

Denim
Ocean
Midnight
Indigo

Slate
Larkspur
Sky
Cornflower

Teal
Lapis
Hyacinth
Sapphire

Tending

Today, extraordinary human and environmental loss is laid bare, raw and intense. The British theologian and novelist Charles Williams wrote of "substituted love"—the notion that through acts of love we can ease the anxiety and even the physical pain of others, whether they are family and friends or strangers. <u>We all have the capacity to hold a thought, a loved one, even our flawed world, up to the light to see how they shine.</u>

Tiny and far from showy, *Tulipa polychroma* is a species of tulip native to steppe regions of western Asia. The bulb blooms in early spring, with subtle colors that mirror those of our precious, fragile, resilient blue-green planet. A subtle reminder to focus on our impact on the people and places that are our privilege and our responsibility to tend.

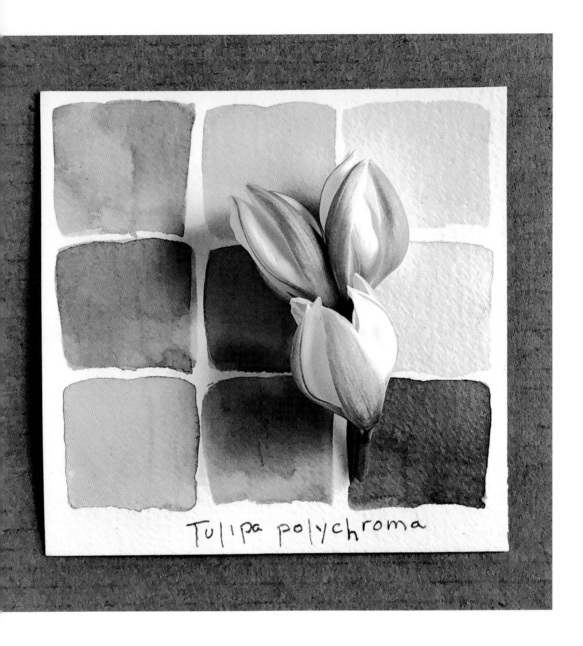

Tulipa polychroma

ildflower tulip
ulipa polychroma)

Bulb,
4 to 5 inches (10 to 12 cm),
full sun, zones 3–8

seafoam
ivory
olive
teal
sapphire
grass green

Blue

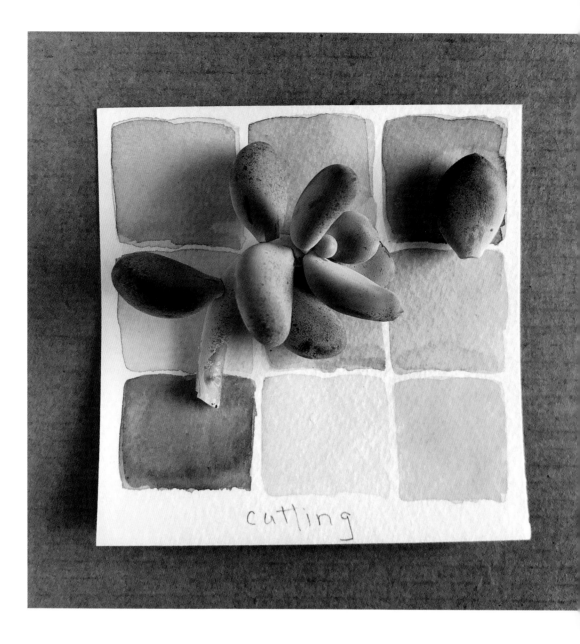

cutting

Unknown succulent
(Possibly *Pachyveria
scheideckeri*)

Perennial,
6 inches (15 cm),
full sun, zone 10

teal
turquoise
buff
smoky
lime
graphite

Cuttings and Connections

I spent sixteen years working in retail horticulture, thirteen of those as co-owner, and then sole owner and operator, of Fremont Gardens, a small specialty nursery that traded in choice plants and cultivated a community of passionate plants people. It was an immersive affair, my every sense keenly attuned to the weather—and cash flow.

Flower shows, plant sales, and nursery life in general can be a wild ride, with much heavy lifting, shifting of containers, and sorting through inventory. Things break. Years ago, on an especially hectic day, a nursery friend handed me a piece of a succulent that had broken in transport. "Here," she said, before rushing away to tend to her many tasks.

Once home, I set my succulent fragment on a windowsill to heal for a week or so, before sticking it in a tiny pot of gritty soil. Cells formed in the resulting calloused tissue are primed to produce roots—nature is amazing. My hand-me-down succulent has been with me ever since. I'll pass this cutting on to a friend.

An Equation for Miracles

In the late twentieth century, a British math professor proposed that, on average, each of us could expect to experience a bona fide "miracle," defined as an event with one-in-a-million odds of occurring, roughly once a month. John E. Littlewood came up with his theory, which he called Littlewood's Law of Miracles, by calculating that during every waking hour a person perceives about one event every second.

Simple math—8 hours × 60 minutes × 60 seconds = 28,800 seconds a day—reveals that in a little more than thirty-four days each of us will have perceived one million events. Ergo, by Littlewood's definition, one of them must have been miraculous. Yet some people believe that the professor was cynically debunking miracles, using their frequency to make them commonplace.

If that is so, I beg to differ with the learned gentleman. One glimpse of the tender blooms of 'Valerie Finnis' grape hyacinth is proof enough for me.

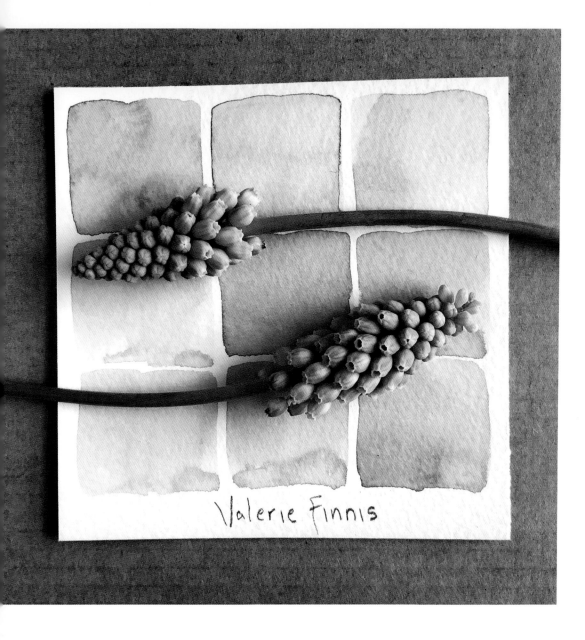

'Valerie Finnis' grape
hyacinth
Muscari armeniacum
'Valerie Finnis')

Bulb,
4 to 6 inches (10 to 15 cm),
full sun to part shade, zones 4–8

lake
sky
heavenly blue
sapphire
larkspur
hyacinth

Blue

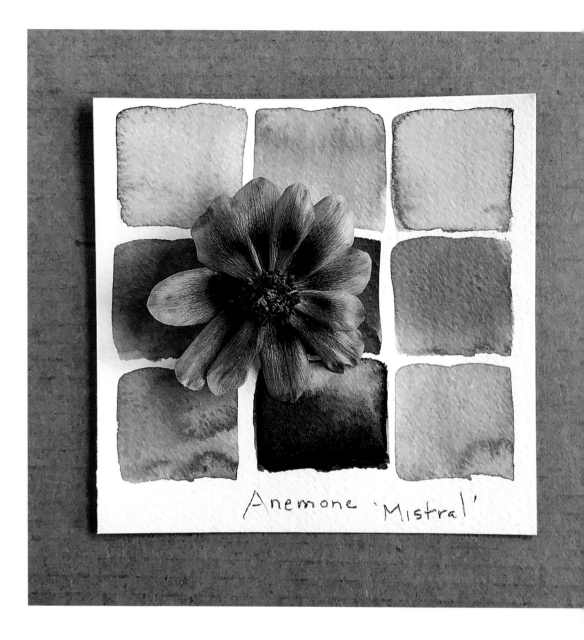

Anemone 'Mistral'

'Mistral Blu' poppy anemone (*Anemone coronaria* 'Mistral Blu')

Perennial but often grown as an annual in cutting gardens, 8 to 10 inches (20 to 25 cm), full sun, zones 7–10

cobalt
denim
borage
sky
midnight
larkspur

Blue Notes

At first glance, blue is everywhere in the natural world. From the benediction of bluebird skies to vast oceans, lazy lowland rivers, and still mountain lakes, blue is expansive. Receding into the distance, blue cultivates spaciousness and invites calm. Yet, <u>in the world of flowering plants, fewer than 10 percent produce truly blue blooms</u>. Abundance and scarcity. Maybe that's why blue holds a special place in most gardeners' hearts.

I felt like I found a botanical unicorn when my patch of anemones served up this 'Mistral Blu' bloom. The mistral is a strong, cold and dry wind that scours the landscape in the South of France, typically marking the transition from winter to spring.

Remember

Rosemary is a sturdy aromatic herb with a resinous flavor that's native to the Mediterranean but thrives in my garden in the northwestern United States. Its genus name, *Rosmarinus*, means "dew of the sea," and even if your shore leans chilly and foggy, rosemary encourages the mind to drift back to dry scrubby cliffs and a hot, sun-soaked clime. The plant flowers in fits and starts all winter, before flushing with brilliant blue-purple blooms in spring, as if beckoning back blue skies after months of gray damp.

Plant rosemary where it can bask in full sun, preferably no more than a few steps from the kitchen so it's easy to snip a sprig to top an olive-oil-rich bread, stuff a roast chicken, or add depth to tomato sauce. Like lavender, a companion herb in the classic herbs de Provence mix, along with thyme, marjoram, basil, and others from the Provençal region, rosemary shifts easily between savory and sweet—roasted potatoes or pound cake, grilled lamb or lemonade. Add a sprig to an icy gin and tonic on an especially warm day. Yes, please.

Poets say rosemary is for remembrance. Whether you're conjuring up a past vacation or holding in your heart a loved one who's gone, memory connects past and present.

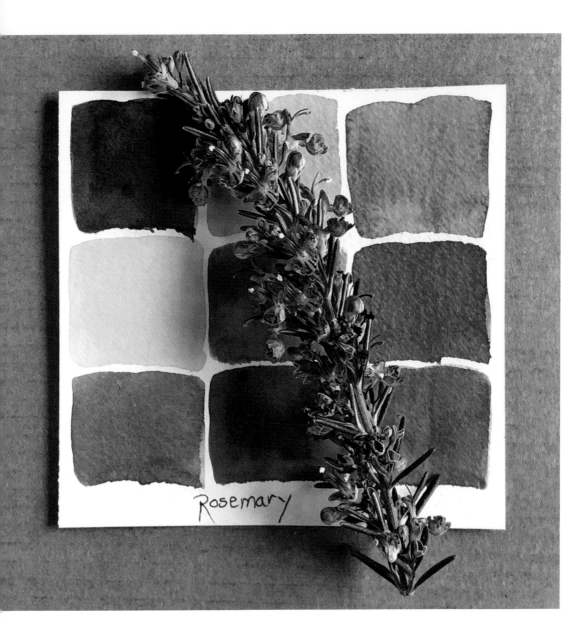

Rosemary
(*Rosmarinus officinalis*)

Woody perennial,
size varies, full sun, zones 7–11

cornflower
sky
cerulean
olive
gentian
umber

Blue

Cornflower

Cornflower
(Centaurea cyanus)

Hardy annual,
12 to 36 inches (30 to 90 cm),
full sun, zones 2–9

cornflower
cobalt
sapphire
cerulean
lapis
larkspur

132

Blue Door Days

Cornflowers get their name from their propensity to show up in fields of grain ("corn" traditionally referred to all grains). To this day, farmers consider the plant to be a noxious weed, contaminating fields and corrupting the harvest.

The rest of us simply see **brilliant blue blooms, as if a piece of sky has fallen to earth**. Celestial and humble in equal measure, cornflowers are treasured by home growers and cut flower farmers for their cottage charm and easy-to-grow disposition.

There was a time when all the interior doors in our home were painted cornflower blue. Every significant day in the life of our household was captured in a photo in front of a blue door, from kindergarten to prom to college to the first day of a new job. These days, most of the doors have been repainted, but "blue door days" remain a part of the loving lexicon of our family.

Floral Confetti

Celebrate your own blue door days with this botanical confetti made up of heavenly hues.

Suggested flowers:
Borage
Cornflower
Honeywort
Italian bugloss
Larkspur
Pansy
Statice

For the best color, harvest blooms that are newly opened; any browning on the petals will only be accentuated once dried. Bundle stems and hang them upside down in a warm, dark, dry location, like a closet or the garage. Depending on ambient humidity and the size of your blooms, the petals should feel dry and almost crispy in about a week. Since we're using only the petals for our floral confetti, you don't need to wait until the entire flower head is dry. Remove petals and store in a paper box or sealed glass jar, out of direct sunlight.

In a very humid climate, or if your celebration is imminent, you can use a microwave to speed the drying process. Harvest blossoms as above. Pluck individual petals and arrange them in a single layer on a microwave-safe plate lined with a paper towel or cotton napkin. Cover petals with another layer of toweling and microwave in thirty-second bursts until petals are completely dry. Allow to cool completely before storing.

Borage for the Bees

Heavenly blue blooms that look like shooting stars and contented bumblebees hover above a gangly tangle of bristly stems and leaves. The borage is blooming. The blue-fading-to-pink blossoms, as well as the succulent stems and leaves, smell and taste like a mild cucumber. Garnish summer salads and desserts with the blossoms, or add a sprig to a Pimm's Cup, a refreshing gin cocktail.

It's easy to lose track of time watching the bees buzz about the plant's furry flowers in the vegetable garden as you tie up the tomatoes and pick beans. Pollinators and beneficial insects of all sorts adore the nectar-rich blossoms. Borage is easy to grow and isn't fussy about soil or moisture, once established. However, the plant will seed wantonly about, though the profligate offspring are easy enough to remove from where they're not wanted.

In traditional herbal lore, **borage was thought to instill courage and ease melancholy**. So, whether you're garnishing a cocktail, girding yourself to face down challenges, or simply lazing away an afternoon in the company of contented bees, borage is a thoroughly pleasant garden companion.

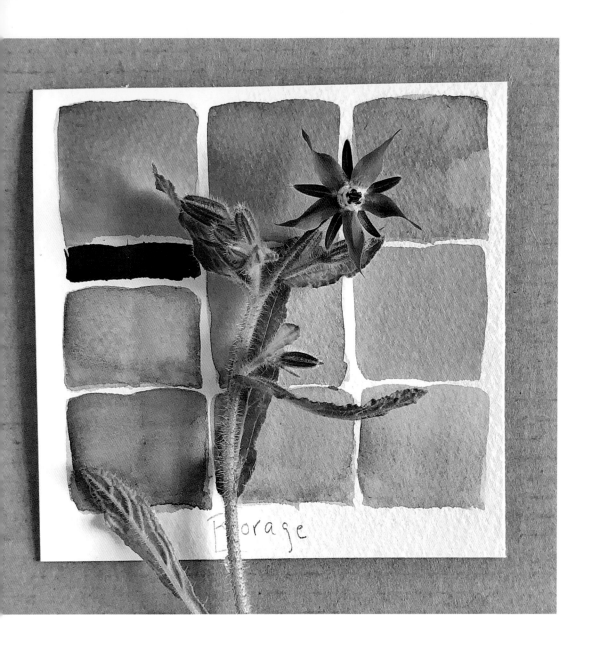

Borage

orage
(*Borago officinalis*)

Hardy annual,
2 to 3 feet (.6 to .9 m),
full sun to part shade, zones 2–11

heavenly blue
sapphire
borage
celery
cobalt
grass green

Blue

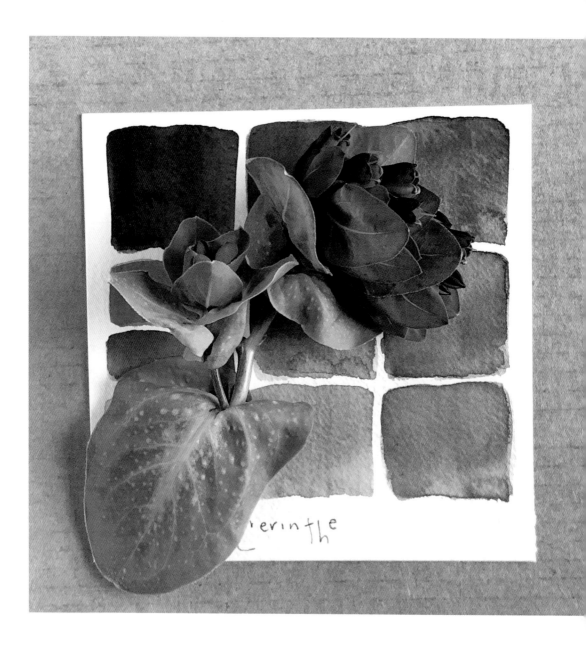

erinthe

Honeywort
(*Cerinthe major*
 'Purpurascens')

Annual,
1 to 3 feet (.3 to .9 m),
full sun, zones 2–9

midnight
cerulean
teal
cobalt
indigo
lapis

Tides

Several years into this daily garden watercolor practice, I look forward to seasonal rhythms and painting familiar plants. That said, every year honeywort, also known as the blue shrimp plant, strikes a little terror into my color-loving heart as I attempt to capture its remarkable hues, more undersea garden than backyard bloom.

Any sort of daily practice has its tides, the high and the low—and the slack. This one is no exception. Water and pigment occupy and focus the mind and satisfy a simple desire to capture something that, like the tide, cannot be stilled for long. The mind quiets and goes calm. Then again, sometimes I can't even get off the beach. But then the day rolls over and I get to try again.

Garden Life

Tending to a garden, with all its attendant thrills and spills, is a sometimes-wild ride. Awkward tan lines, calloused hands, and the occasional scar from an encounter with a hose that wasn't put away properly physically trace the accumulation of growing seasons and signal our membership in a tribe that embraces digging, lifting, and toiling in all kinds of weather.

I imagine the plant breeder who named 'Black and Blue' anise-scented sage was more likely referring to the plant's spires of electric cobalt blue blossoms held in inky black calyces than a garden's wear and tear on our bodies. All the same, the plant's glorious summer display of dramatic blooms atop lush, green, aromatic foliage reminds us that our efforts are all worthwhile.

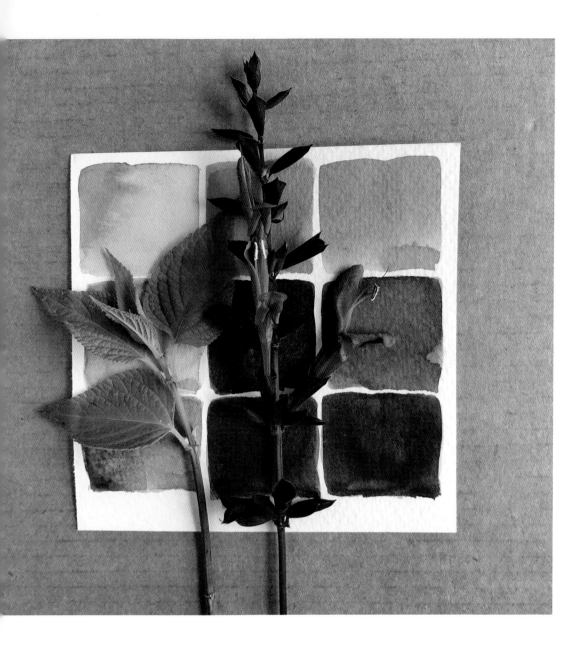

anise-scented sage
Salvia guaranitica
('Black and Blue')

Perennial,
3 to 4 feet (.9 to 1.2 m),
full sun, zones 7–10

borage
cobalt
sapphire
indigo
navy
grass green

Blue

Indigo

In the late seventeenth century, Isaac Newton's experiments revealed that white light refracted through a prism produced a spectrum of seven visible colors, which have been codified into the colors of the rainbow as we (mostly) know them today—the jury is out on whether indigo, the transition between blue and violet identified by Newton, has truly earned its place in the rainbow.

As we proceed through a rainbow of color studies, when we get to indigo we have to look up from the garden and take in the world around us. Notice how morning light is cool with a blue cast. Sunny days create high contrast and dark shadows. Indigo lives in those shadows—look closely and see if you don't agree.

While indigo is absent or relatively rare in flowers, the dark center of poppy anemones, one of my favorite flowers, is a remarkable exception. I think the pollen-dusted stamens look like streaks of mascara running down a tear-stained face. Poppy anemones begin flowering as early as three months after a spring planting and continue to produce their eye-catching blooms for weeks. In areas with mild winter temperatures (zone 7 and above), anemones may be planted in fall for an even more prolific bloom season.

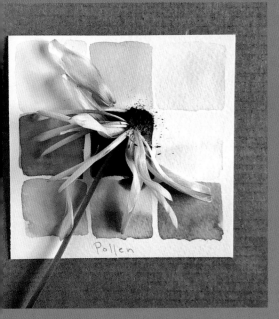

Pollen

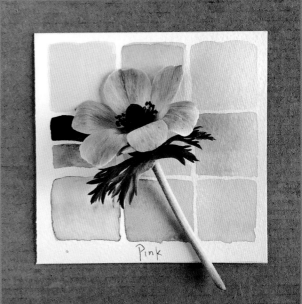

Pink

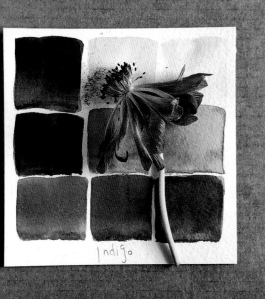

Indigo

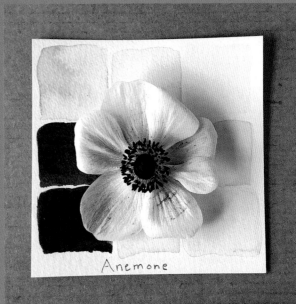

Anemone

Violet

Purple	Iris	Wine	Grape
Plum	Mauve	Lavender	Orchid
Heliotrope	Puce	Heather	Blueberry
Eggplant	Blackberry	Lilac	Amethyst

Holi

Hindus mark the end of winter with a bonfire that's meant to consume bitterness and restore broken relationships. The following day, Holi, celebrants take to the streets, singing and dancing and playfully dousing one another with plumes of colorful powdered pigments in <u>a communal welcome to spring and a riotous rainbow of love and harmony.</u>

Many traditional Holi delicacies and drinks include saffron, a costly spice produced by a species of fall-blooming crocus that must be laboriously harvested by hand. Fortunately, saffron crocus is easy to grow in a pot on a sunny patio. In late summer, plant a dozen small corms two inches (five cm) deep and about the same distance apart in a container filled with a well-drained organic potting mix. When blooms appear a few short weeks later, carefully pluck the vivid crimson threads, or stigmas, from the center of each flower. Your harvest will be modest but powerfully flavorful. Thoroughly dry your fresh saffron in a warm place and store in a closed container. Allow the plant's grassy foliage to ripen and die off on its own, then let the container go dry in summer when the plants are dormant.

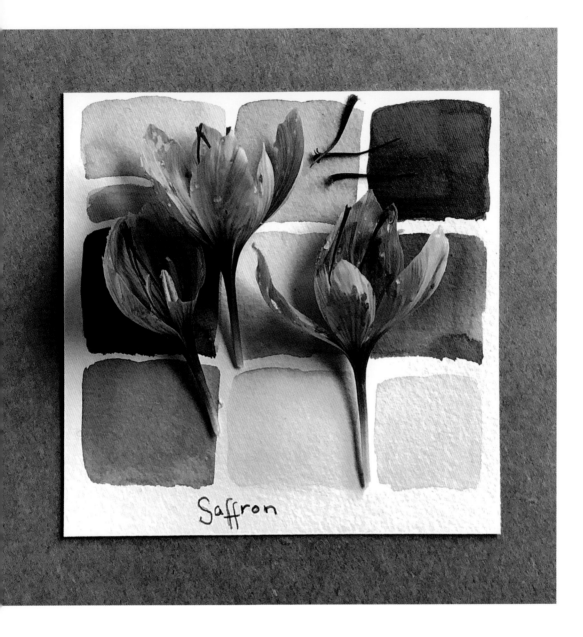

Saffron

saffron crocus
(*Crocus sativus*)

Bulb,
8 to 10 inches (20 to 25 cm),
full sun, zones 6–9

violet
purple
lilac
wisteria
goldenrod
saffron orange

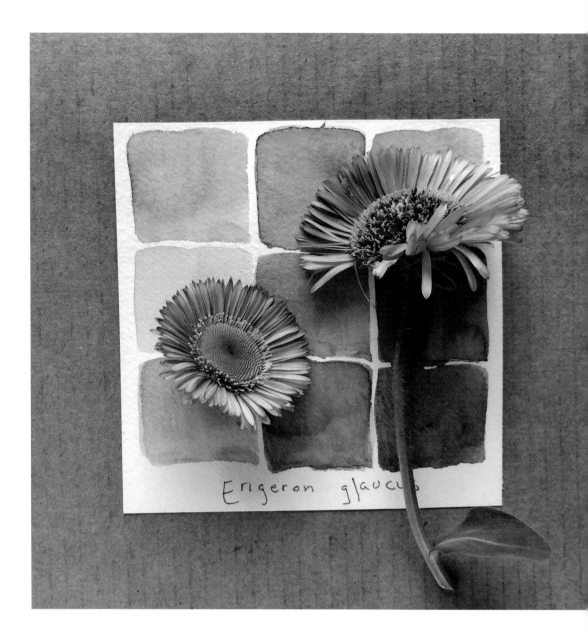

Erigeron glaucus

Seaside daisy
(Erigeron glaucus)

Perennial,
6 to 12 inches (15 to 31 cm),
full sun, zones 5–8

lavender
lilac
purple
goldenrod
olive
emerald

The Hospitality of Native Plants

With ease and natural grace, **native plants ground the garden**, establishing a presence that extends beyond planting beds and property lines. With every bloom they declare: *This is my place. These are my creatures. We belong here.* While deeply wild in the truest sense of the word, many native plants have a domestic side and play nicely with nonnatives in mixed plantings.

Seaside daisy is a ground cover native to the West Coast of America. A low cushy mound with evergreen foliage, the plant produces nearly constant waves of semidouble lavender blooms with sunny yellow centers from mid-spring to late summer. As its common name suggests, seaside daisy thrives in coastal conditions, tolerating wind, salt spray, and dry growing conditions. Butterflies and other pollinators flock to the nectar-rich blossoms. Later in the season, juncos and finches swoop in to harvest the seed heads.

Humble and Helpful

Beware of planting a garden full of nothing but divas, all flashy petals and colorful high notes. Lavishing love and attention on demanding plants quickly turns tedious, exhausting the attention of even the most ardent gardener. Give me a supporting cast of no-nonsense, drama-free plants, and I'll show you a happy gardener and a harmonious landscape.

Box leaf honeysuckle is a handsome garden backup player. Left unsheared and shaggy, it has a demeanor that is definitely more workhorse than glamour. But, like its boxwood namesake, this low spreading shrub takes well to clipping, and can carry a trim formal look with aplomb. A closer look at this pest-proof, drought-tolerant, evergreen shrub reveals discreet fragrant flowers in spring, followed by glossy amethyst berries in winter—a favorite of birds and of contented gardeners who know to look for them.

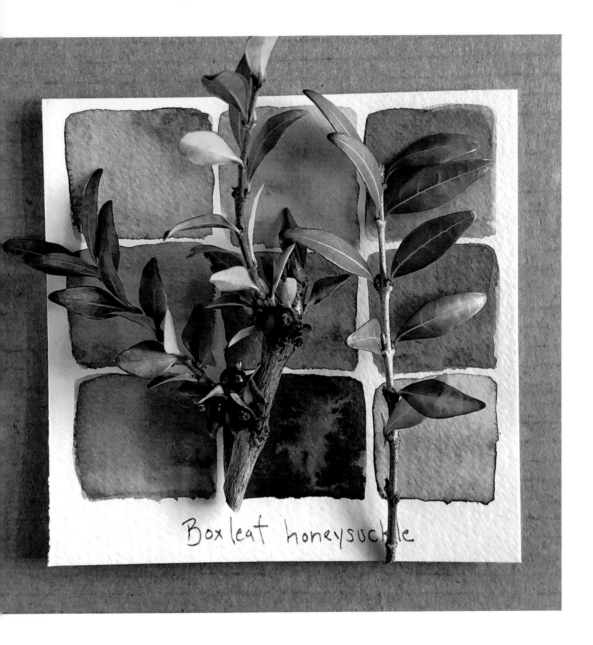

Box leaf honeysuckle

Box leaf honeysuckle
(*Lonicera pileata)*

Evergreen shrub,
1 to 2 feet (.3 to .6 m),
full sun to part shade, zones 6–8

olive
lime
emerald
bronze
amethyst
purple

Violet

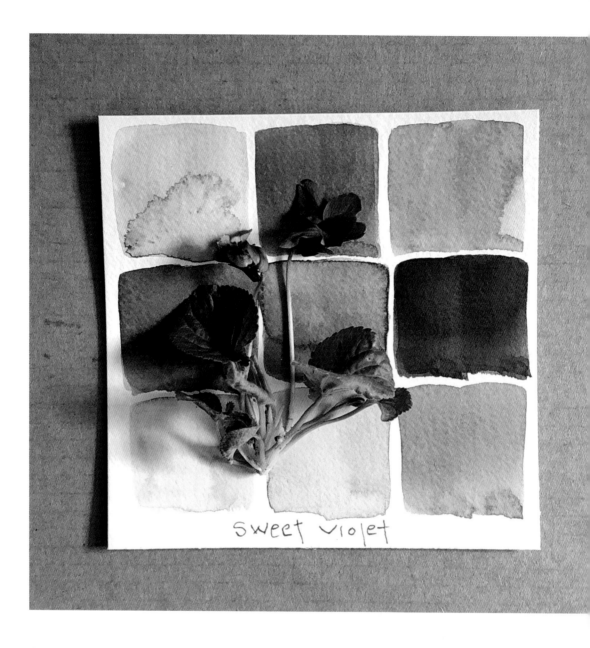

sweet violet

Sweet violet
(Viola odorata)

Perennial,
4 to 6 inches (10 to 15 cm),
full sun to shade, zones 6–8

violet
lavender
purple
lilac
emerald
grass green

Mud and Magic

The sweet violets are blooming. I admit they're weedy. I love them so. Scattered along the fringes of my garden beds and borders, today's plants are the progeny of a single four-inch nursery pot purchased in the late '90s. The plants have survived complete neglect and massive renovation in equal measure.

Besides their resilient constitution, the singular appeal of my very humble violets is their sweet, slightly cloying perfume. And magic. **The fragrance of sweet violets can be detected only in brief, intense intervals.** One moment, you'll catch a powdery aroma on the breeze—then nothing but mud and wet knees in the chilly spring garden.

OK, so it only seems like magic. The plant's fragrance contains ionones, compounds that temporarily desensitize scent receptors in the nose, blocking your perception of the violet's perfume. Once the nerves recover, you'll catch another whiff—and so on, and so on. Transient and lovely, like a flash of sun on a damp day.

Violet

Older Now

With its many insistent tasks, the garden is a permissible escape from indoor responsibilities. Aimless minutes at the end of a hose appear practical and purposeful, while the sound of trickling water soothes a fractious spirit. And, while it pains me to admit it today, planting and pruning offer welcome relief from the relentless nature of parenting.

Still, my garden grew me into being a better mother. In the company of flowers, I learned to accept and embrace the brilliant and the mundane; to cherish or endure brief moments but always adopt a long view. Today, my children are grown, with responsibilities of their own. But I'm still here, puttering with plants, offspring that grow but never quite achieve independence.

This heirloom larkspur is a humble, easy-to-grow annual that readily reseeds about the garden. Blooming in tarnished shades of lavender, amethyst, and sterling, it helps me to recognize the gifts of aging and to look at all of creation, including myself, with compassion.

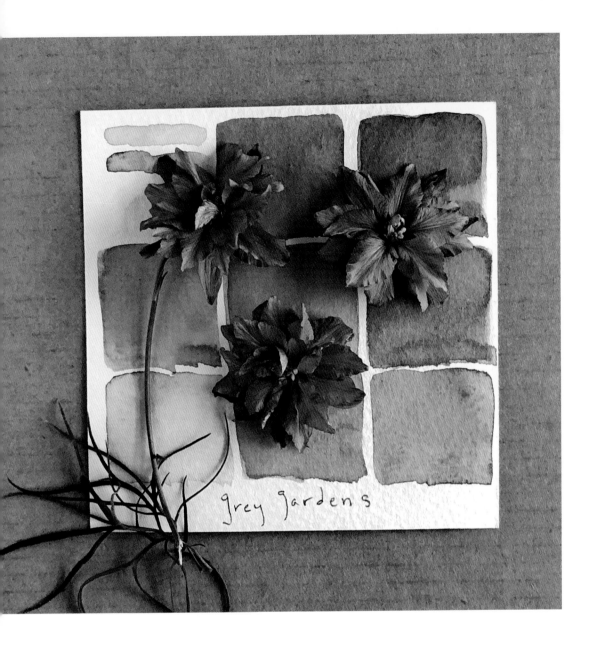

Larkspur 'Earl Grey'
(*Consolida ajacis*
'Earl Grey')

Annual,
3 to 4 feet (.9 to 1.2 m),
full sun, zones 2–9

amethyst
lavender
lilac
sterling
wisteria
mauve

Violet

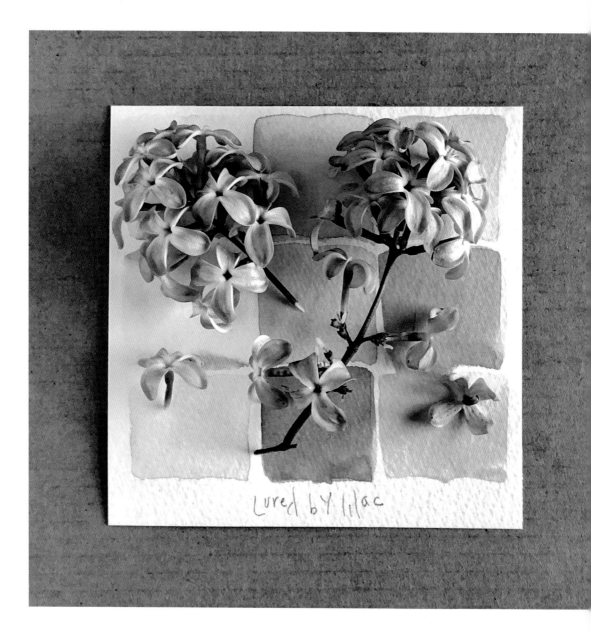

Lured by lilac

Common lilac
(Syringa vulgaris)

Woody shrub,
8 to 10 feet (2.5 to 3 m),
full sun, zones 3–7

lilac
lavender
rose
purple
mauve
violet

Lilacs and Petty Larceny

I never, never, ever pick flowers that aren't mine without permission. Unless a lilac happens to be leaning over an old fence into a dark alley and it is nearly midnight under an almost full moon in late April.

The charms of lilac season are brief but intense. How an awkward shrub with nondescript foliage can produce such elegant, lax panicles in watercolor shades of rose, dusty pink, and, well, lilac is almost the stuff of fairytales. And, as if that's not enough, the bewitching blooms are richly scented. But don't look away. Their spell is fleeting, but sufficient to lure countless gardeners into devoting growing space to this two-week wonder. Thank goodness!

I blame the silvery moonlight and intoxicating fragrance. I'm not sorry.

Violet

Critical Thinking

Like many of us, I am my own harshest critic. It's a rare day that finds me satisfied with every swatch in my color study. Especially when I'm trying to match purple plants.

Theoretically, purple is a secondary color that results from mixing red and blue, two primary colors. But more often than not, that simple formula produces nothing but a muddy mess, a lifeless, disappointing hue.

Violet is a spectral color created by short wavelengths of light, and it has the highest energy and frequency of any color on the visible spectrum. Sometimes energy defies pigment. Yet even a short list of the various names that purple goes by—lavender, lilac, orchid, plum, amethyst, eggplant, blackberry—demonstrates how common the color is in nature. It seems that light and living tissue are key to capturing this elusive hue. **Practically speaking, avoid undue frustration by supplementing your paint palette with a true purple pigment.**

In addition to color, fragrance and flavor draw us into a relationship with our plants. A sweet spot in the garden for humans and pollinators alike, the luminous purple blooms and the green foliage of anise hyssop smell and taste like licorice.

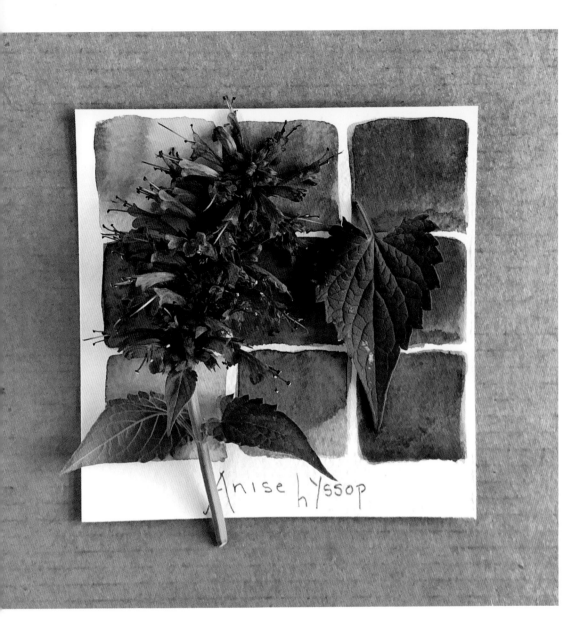

nise hyssop
(*Agastache foeniculum*)

Perennial,
1 to 3 feet (.3 to .9 m),
full sun, zones 4–10

violet
purple
mauve
amethyst
grape
emerald

Violet

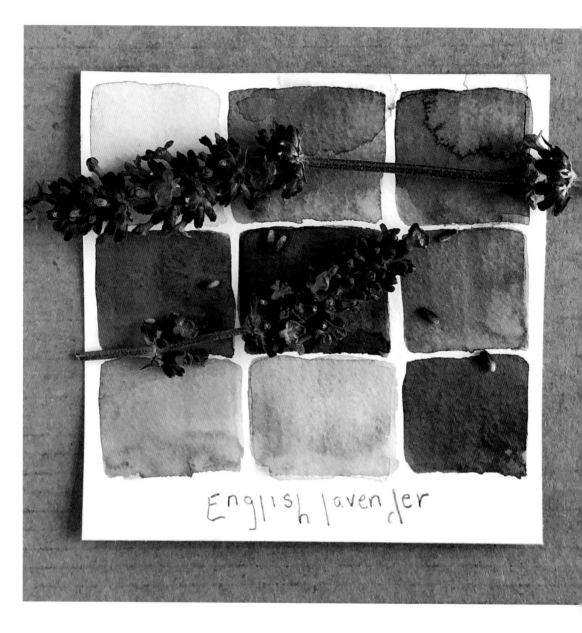

English lavender

English lavender
(Lavandula angustifolia)

Woody herb,
12 to 18 inches (31 to 46 cm),
full sun, zones 5–8

lavender
purple
celadon
violet
grape
heliotrope

A Lavender Lullaby

Another color that thinks it's a plant. Or is it a plant that thinks it's a color? Contemplate this riddle as you lie on a soft blanket on a hot sunny day in a field of aromatic lavender, accompanied by a chorus of contented bees. Our association of this familiar Mediterranean herb with relaxation is so strong that just reading that sentence, you probably felt your shoulders relax and your brow begin to soften.

Lavender is potent. Too much for some. Never enough for others. All parts of the plant, not just the blooms, are infused with volatile oils, a redolent floral mix tempered with camphor and flint. A popular aromatherapy oil, lavender relieves stress, promotes sound sleep, and can even be used as an adjunct treatment for alleviating depression and anxiety.

Gardeners can choose to grow a variety of lavenders, each with a different flowering and growth habit. English lavender has a compact form, silvery green foliage, and exceptionally fragrant, dark purple bloom spikes.

Lavender Honey

Capture the flavor and scent of a Mediterranean summer and hold on to it for the coming cold months with this quick and easy lavender-and-honey infusion.

You'll need:
1 cup (240 ml) honey
15 to 20 fresh lavender
 flowers, or 1 tablespoon
 dried lavender

Gently warm honey in a small saucepan on the stovetop or in a heatproof bowl in the microwave using short bursts, just enough to bring up the temperature and liquify the honey.

Stir lavender into the warm honey and set aside to steep for 24 hours. Your kitchen will smell deliciously heady.

After steeping, rewarm the honey just until it's of a pourable consistency. Strain honey into a jar, using a small wire sieve to remove flowers. Or, for additional flavor, leave the now-candied blossoms in the honey.

Stir your lavender honey into plain yogurt or mix with fresh berries. As time passes and summer turns to fall, use lavender honey to sweeten hot tea or warm milk, anoint a roast chicken, or drizzle over goat cheese and serve with crackers and dried fruit. But perhaps its highest calling is to be slathered on buttered toast.

Affirmative Possibility

A wise and compassionate writer once said, "It gets better." Not to say it doesn't sometimes still break us into shards. Love and loss are brutal twins. By definition, one sets you up for the other.

This project is only in part about the garden. From the beginning, my goal was to heal from grief. **Daily practice and working with my hands are restorative,** but, more important, they have helped me discover the affirmative possibility of peace and joy even in the midst of pain and loss.

The darkness is real. Isolation, anxiety, and the hopelessness of facing more of the same; at times, the struggle is relentless, the suffering unbearable. Until it's not. The taste of life on the other side is sweet. Reach out and hold those you love dearly. Tell them it gets better. And perhaps take them to a garden to see color and light.

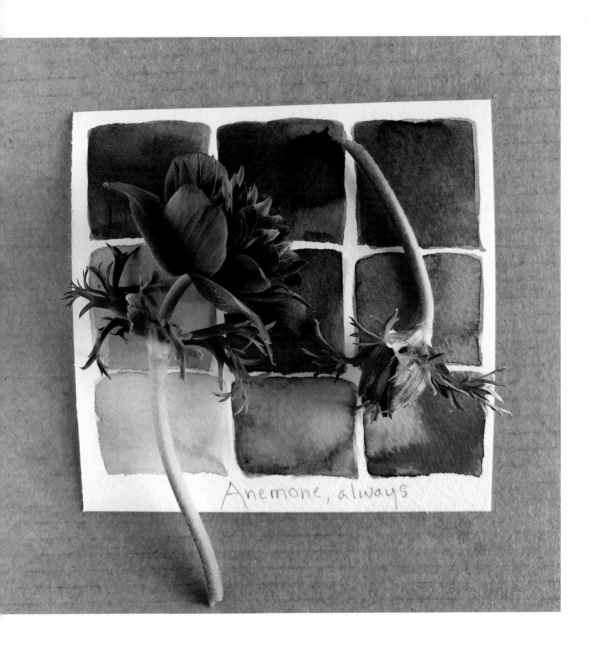

Anemone, always

Poppy anemone
(*Anemone coronaria*)

Perennial but often grown as an
annual in cutting gardens,
8 to 10 inches (20 to 25 cm),
full sun, zones 7–10

purple
grape
blackberry
lavender
heliotrope
iris

Violet

Wine

Cultivating color—whether in the garden, or by painting swatches of watercolor, or with words on the page—brings me joy. Like a bumblebee wantonly belly flopping from blossom to blossom in a field of flowers on a summer day, I am completely besotted in the company of green, orange, violet, and countless other hues.

Training our eyes to forage for color, in and out of the garden, is a playful exercise that's pleasing and instructive. Like savoring a mouthful of fine wine to tease out nuanced flavors, consciously noticing color activates pleasure centers in our brains that might otherwise be overlooked in the crush of life.

At the risk of becoming repetitious, this daily practice doesn't aspire to botanical illustration—leave that exercise to others. Instead, think of yourself as an attention artist making marks in watercolor.

When all is said and done, indulging in color, even in immoderate measures, is really pretty tame. **The power is in learning to see.**

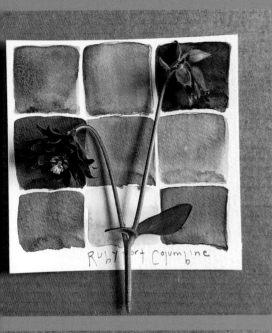

Ruby Port Columbine

'Pippa's Purple' he

honey garlic

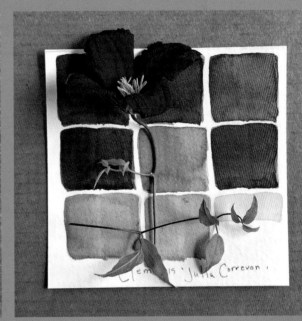

Clematis 'Julia Correvon'

What Do You See?

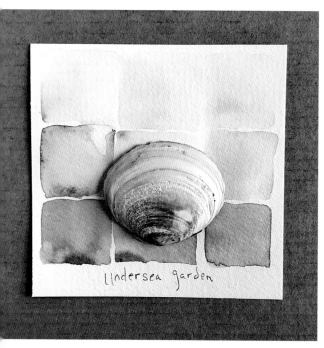

undersea garden

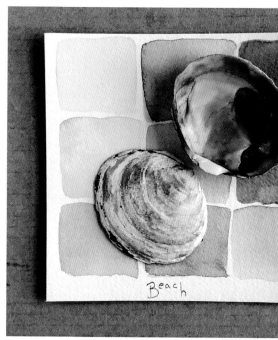

Beach

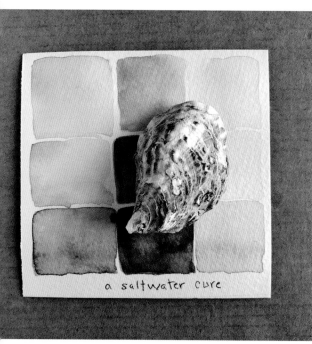

a saltwater cure

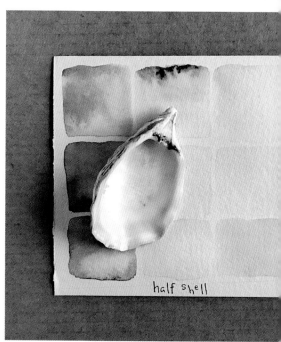

half shell

A Daily Practice

The beauty of a daily painting practice is its constancy and its forgiveness. We always get another chance. Over time, your color mixing and brushwork *will* improve, as will your observational skills. I routinely record the colors of the shells that I leave scattered about my desk. I appreciate the way they connect me with the tides, another rhythm that's constantly ebbing and flowing. Shells are my scales, technical exercises that I practice again and again to flex my perception and improve my interpretation. The subject may be the same, but the light is different, I'm different. The Japanese call this *ichi-go ichi-e*, which can be translated, loosely, as "for this time only." Each blossom, each breath, each painting captures a once-in-a-lifetime moment.

This final chapter is an invitation to begin your own simple color practice. Making time to look deeply and allow color to focus our attention subtly—or sometimes not so subtly—enriches the way we see the world. Expanding our ability to recognize the generous multiplicity of color informs our creativity across a variety of disciplines, in and out of the garden. The clothes we wear, how we furnish our home, how we plate up a meal—color has the power to move us. This is a gift we can share with others.

I'll share what my daily practice looks like, but I encourage you to follow your intuition and do what feels right to you. Only you can express what you're seeing.

All you need to begin creating color studies are paints, a brush, a glass of water, a surface on which to mix your colors, and paper to paint on. Paper towels or a cotton cloth are handy for drying your brush, and a level work surface helps keep your very liquid colors where you put them.

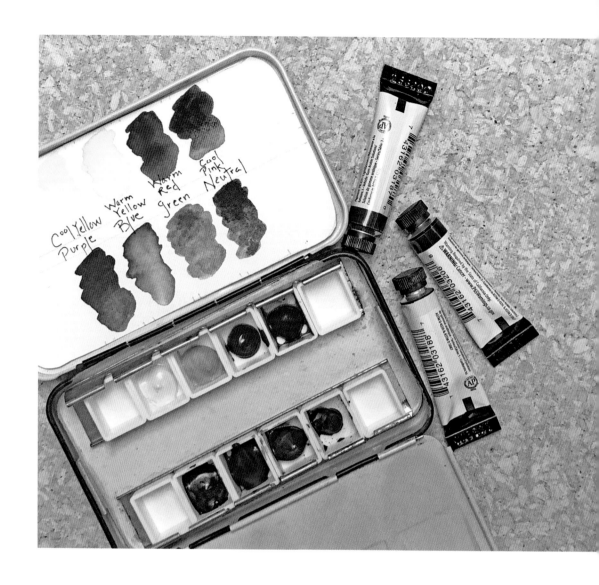

Paint

Choosing watercolor paint, either by quirky proprietary names or by technical pigment names, can feel overwhelming and foreign. There are *so many* colors! First, you need to decide whether to work with pan or tube pigments, then you'll choose between artist- or student-grade paints. Various pigments and paint formulas have different grades for lightfastness, performance, and clarity. Brands vary wildly, as do prices.

Relax, you don't need fancy paint. When I began this practice, I simply used what I had on hand, a craft store watercolor set filled with Chiclets of chalky paint and colors that were more garish than garden. But, with daily use, I became familiar with my paints and comfortable with the visual vocabulary I developed with them. Later, I treated myself to finer paints with more saturated and nuanced colors. Would I go back? Probably not, but I learned a great deal exploring the range and limitations of that original, humble palette.

Watercolor pan sets come in nearly infinite combinations, and for years I stuck with ready-made pan palettes. In fact, I amassed a bit of a collection. One set had a nice clear yellow, another one had an indispensable lime green, the color of fresh growth in the garden. Over time, I noticed that some paints in these pan palettes became my go-to pigments for mixing garden colors, while others remained untouched. Inadvertently, I reverse engineered a limited palette of basic hues that lets me mix the broadest range of colors that I see in my garden's bits and pieces.

You may decide to work with tube watercolors, thick saturated pigments that you squeeze out in small daubs—a little goes a long way. Even though it sounds like an extra step, your freshly squeezed paints will be easier to use if you let them dry first. Working with tube pigments also allows you to mix and match brands and grades to build a palette that suits your color preferences and budget.

What Do You See?

You'll likely develop your own favorites, but here are the colors I use, day in and day out. Note that following my description of the nature of each color, I've included a few of the pigment names you'll find on paint labels, for easy reference.

* *Cool yellow* is a clear yellow, pure without a touch of orange (Hansa yellow, lemon yellow).

* *Warm yellow* is burnished; think of the golden sun (gamboge, cadmium yellow, chrome yellow).

* *Warm red* leans scarlet, pure red with a touch of orange (cadmium red, vermilion, pyrrol scarlet).

* *Cool pink* is luminous and clean without the opacity of adding white to red (opera rose, quinacridone pink, rose madder).

* *Cool violet* is a true purple, a secondary color that can be challenging to mix from red and blue (dioxazine violet, carbazole violet).

* *Cool blue* is a primary color and a great place from which to start mixing (phthalo blue, Prussian blue, cobalt blue).

* *Warm green* is fresh, leaning lime or olive, with none of that unnatural garden-store-accessory green (sap green, chromium oxide green, green gold).

* *Cool neutral* is a good way to shift colors to more of an earth hue (burnt umber, Payne's grey, Van Dyke brown).

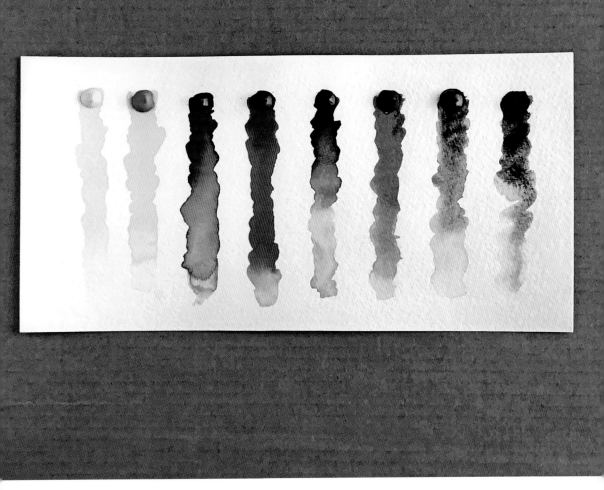

Whichever type of paint you choose, pan or tube, begin by testing and labeling each pure color on a piece of watercolor paper. When mixing your paints, add enough water to the pigment to get a nice "juicy" consistency; watercolor should flow. You'll be amazed at how different paint looks in a pan, on a palette, and on a piece of paper.

Keeping your test sheets together with your paints—I keep mine tucked into the paint pan—makes it easy to reference them as you begin mixing colors. Swatching paints is fun and it's a good way to get to know how each color performs—play with saturation and dilution by varying the amount of water you use; some pigments granulate, or break up into bits, when water is added.

What Do You See?

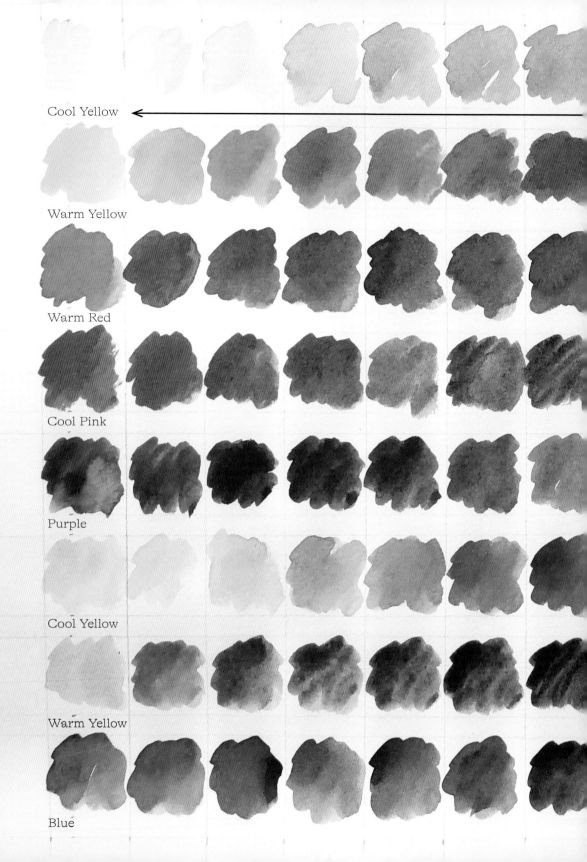

Cool Yellow

Warm Yellow

Warm Red

Cool Pink

Purple

Cool Yellow

Warm Yellow

Blue

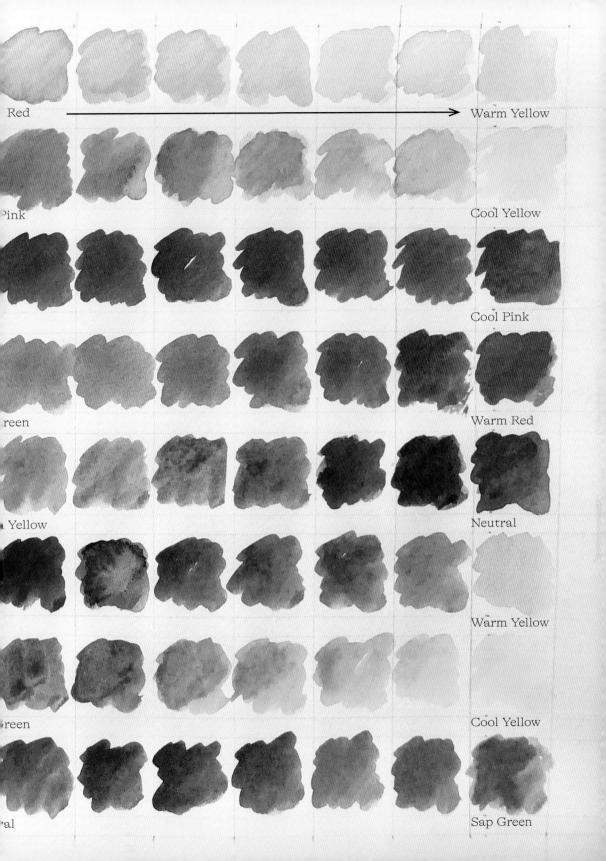

Red \longrightarrow Warm Yellow

Pink

Cool Yellow

Cool Pink

reen

Warm Red

Yellow

Neutral

reen

Warm Yellow

Cool Yellow

al

Sap Green

Charting takes exploration to the next level. You can approach charting colors—that is, mixing pigments in a prescribed way and documenting the results—in a number of ways. A quick online search will reveal numerous possibilities. I like to investigate the range of graduated hues that are possible from mixing two colors together, like what is depicted on the previous spread. Even when working with a limited palette made up of eight hues, like the ones that I've suggested, myriad colors are possible, including some that may surprise you. Remember to save your swatches and note on them what paints you were using, so you have a record to refer back to.

You can also adopt a looser approach and simply play around and experiment. Here are some ideas to get you started:

* *Paint some sample swatches of a single hue.*

* *Add a dab of another color to your previous sample swatch. For instance, add a bit of green to your yellow—or the reverse. There are infinite versions of yellowish green or greenish yellow.*

* *Dilute the colors you mixed with water and see how sheer a wash you can create.*

* *Using your brush, wet a part of your paper before laying down color and see how the paint responds and moves about.*

* *Let wet colors touch and watch how the paints bleed together.*

* *Once a swatch is dry, add another layer, or glaze, on top of it. You can build up the intensity of the same color or choose a contrasting or moderating hue.*

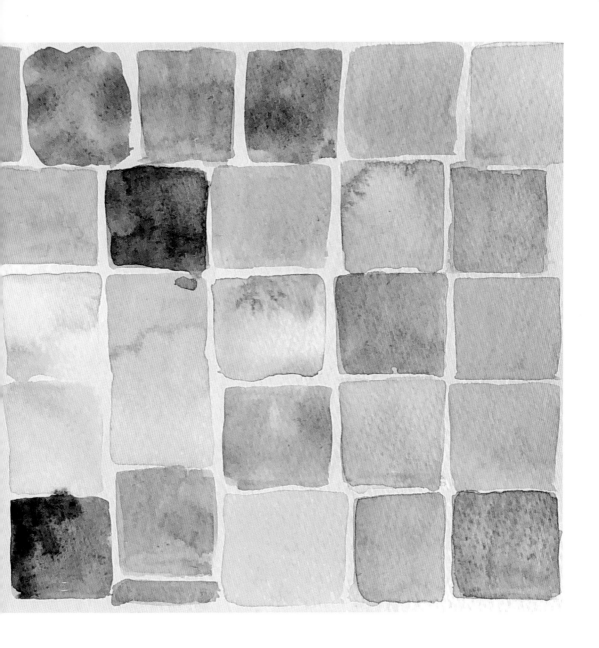

What Do You See?

Brushes and Water

Of course, you'll need a brush, maybe even several depending on what sort of marks you want to make. I began my color study practice using a water brush, because, once again, that's what was stashed in my art supply cabinet. A water brush has a built-in water reservoir in the handle; simply squeeze the barrel to wet your paints and you're good to go—perfect for painting out in the garden. Water brushes come in a variety of tips from rounds that allow you draw a fine line to flat, squared off bristles that are good for laying down broad washes.

Like paint, brushes come in a variety of shapes and sizes and materials, from beautiful natural bristles (and a premium price point) to basic brushes with synthetic bristles. Remember, this practice is about capturing color, not fine art illustration. That said, a brush that feels good in your hand is pleasing and may even enhance your focus.

I spend a great deal of time in my garden, but I paint indoors in my studio. Even though I don't fill it with water, I still use a water brush because its square head makes it easy to create my familiar color study grid and allows me to (mostly) keep the margins between the swatches clean. I've become very attached to those margins. You may decide you want to record your colors by making circles or drawing lines. Maybe you'll even let your colors touch and mingle on the page. It's completely up to you.

Whether you use a water brush or not, I recommend having a clear glass jar of water for rinsing your brush between colors. I have surprisingly strong feelings about this. I prefer clear glass because it allows you to see what color your water is. Most art instructors will tell you to dump out "dirty water" and always start fresh. I don't. For one thing, the water's not dirty, that's pigment. Garden colors are rarely pure. Mixing with slightly, shall we say, "seasoned" water is often just what's needed to shift a hue toward a more natural expression. Except when you're working with yellow. *Always* start with fresh, clean water to depict a clear yellow.

You'll need a palette, that is, a surface on which to mix your colors. Pan watercolors come with a built-in palette, but I recommend giving yourself room to spread out and play. I prefer using a white porcelain palette; white because colors show up accurately, and porcelain because it's weighty enough to not shift and rattle around while I'm mixing. Trust me, the daily racket of a metal mixing pan will drive you to distraction. A simple white dinner plate works nicely, too.

What Do You See?

Like my jar of water, my palette is often "messy." One of my favorite things about watercolor is its ability to be resuscitated. Every last bit of pigment in your paint box and on your palette can be rewet and used to mix future colors. Another good reason to not get too zealous about cleaning up.

A Palette and Paper

Watercolor paper comes in different weights, sizes, and even finishes depending on how it's produced. Hot press watercolor paper is smooth, which makes it easy to capture fine details. Cold press paper has more texture to the surface. I use a sturdy 140-pound, cold press sheet that I cut down to a uniform 4- by 4-inch size. The heavier paper means less warping as the paints dry. I prefer cold press for its organic feel, and the size is a stricture I placed on myself back at the beginning of my practice. Experiment with various papers to see what appeals to you.

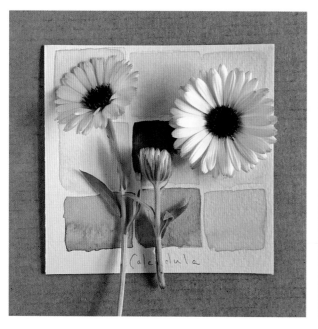
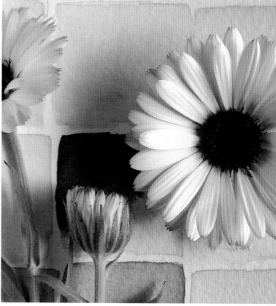

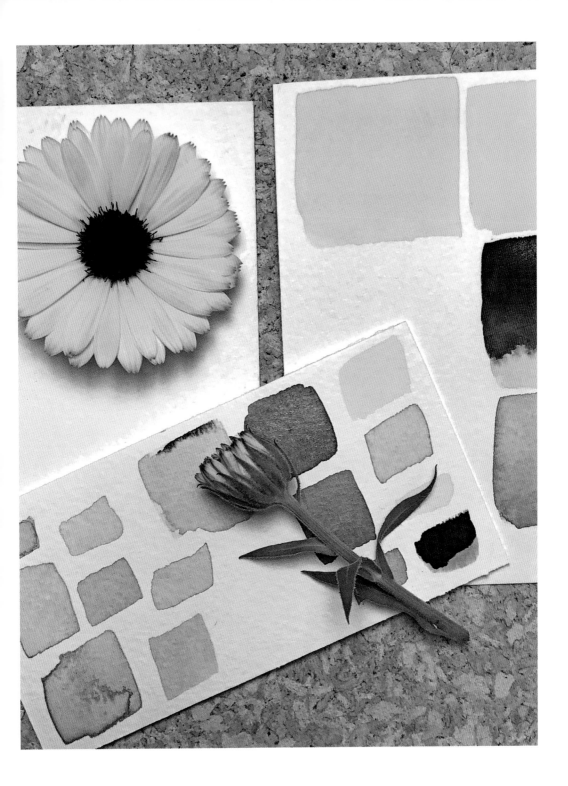

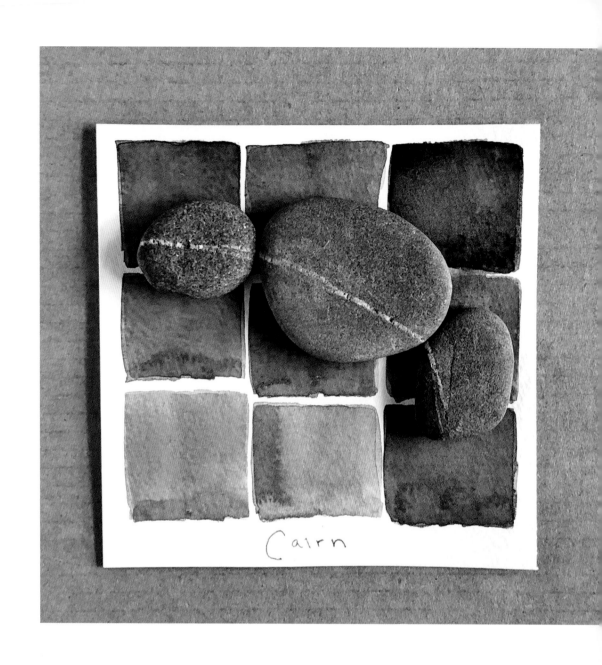

Cairn

Now Begin

Seeing what is easily overlooked, like noticing how the rings on three stones align so neatly, enlarges our view. Someone once told me that a ring around a rock was good for a wish. I think of this arrangement that lives on my windowsill as a sort of linear cairn, a traditional symbol of safe passage. Decide what you're going to paint but don't overthink it— anything that will fit on your paper is fair game. Here are a few prompts to get your creative juices flowing:

* *Identify a section of your garden and log the colors you see once a week for a month, or for a growing season, or even for an entire year. The result will be a very localized signature of place and may inspire future plantings—adding colorful plants to the winter garden is always a good idea.*

* *Pay attention to the uncelebrated; weedy dandelions, untamed sweet violets, and stinging nettles all have charming colors. When you look closely, you'll see the rose is in the thorn as well as the petals.*

* *Or pull back and capture a distant view from a window in broad strokes of color. Do this regularly, and you'll have a colorful record of seasonal changes over time.*

* *Notice nuance. Select a botanical that at first glance is all one color, but on closer examination reveals a multiplicity of graduated hues. Suddenly, every fallen leaf is more interesting.*

Once you have your subject matter, place your selection on a sheet of white paper. This neutral background eliminates distraction and helps you to identify and isolate colors. Placing your botanical on a sheet of paper that's the same size as your watercolor paper is a good way to think about composition, that is, how to place colors on the page to best describe the subject matter. I recommend that you always paint by natural light; incandescent, LED, and compact fluorescent bulbs all cast their own colors, making it hard to see true hues. With the lights turned off, my daily window for painting is significantly limited when days are short in winter, and languorously long in summer; it's all a part of the seasonality of the practice.

What Do You See?

Before you begin, look at the colors in your botanical and ask yourself, Are they warm or cool? I don't mean a literal temperature reading—just the overall cast of the hue. A warm color leans toward yellow—think of the warmth of the sun. In contrast, a cool color leans blue—I find it helps to think of the chill of the night. This step, though hard to describe, will become intuitive as you develop your personal color sense.

When in doubt as to whether a color is warm or cool, it helps to compare it to another version of itself. Look closely at the color study of this rose. The plant's petals contain both warm and cool versions of pink; check out the top two left-hand squares to see what I mean. Let's try a different approach. Green, a dominant color in the garden, is surprisingly difficult to match. Language may help you to clarify and distinguish green's warm and cool nuances. Warm green flushes with lime, olive, and chartreuse, with a golden sunlit cast. Cool green leans toward teal or turquoise—a chill shift toward blue.

As you start mixing your colors, refer to your color test sheets and color charts. One of the best ways to push green toward a more authentic color found in nature is to add a touch of complementary red or reddish brown. Try it. Find the in-between colors; look for where one color ends and another begins.

Test your colors on a scrap of watercolor paper as you mix them and hold your botanical up next to those little daubs and swatches to see if you're headed in the right direction. Once you're satisfied with a color, lay down a swatch on the paper of your color study to record your observation. (See examples on pages 182-83.) Repeat the process as you move on to the next color. And the next.

You'll likely discover that you have a natural affinity for some colors, while others might prove frustrating. I am most comfortable with warm red, orange, brown, and lime greens—not surprisingly, these are the colors I garden with the most. I find blue to be ethereal and hard to capture, and, depending on your paints, purple can be tough to mix. Yellow, as I already mentioned, quickly turns dingy.

I love the immediacy and luminosity of watercolor, the way you can build up sheer layers of color to develop depth and nuance. That said, it can be an unforgiving medium. Keep a light touch. Don't belabor a color that's not working, or you'll end up with a muddy mix and your watercolor paper will begin to shred. Color can't be forced. Some days, it will flow; on others, it decidedly won't. Take a break, rest your eyes. Visual fatigue takes its toll. Over the years that I've been creating these color studies, I've come to the rather obvious conclusion that Mother Nature does this much better than I ever will. Be kind to yourself as you dip your brush and wet your paints. And remember, there's always tomorrow.

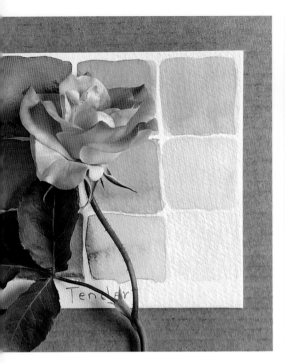

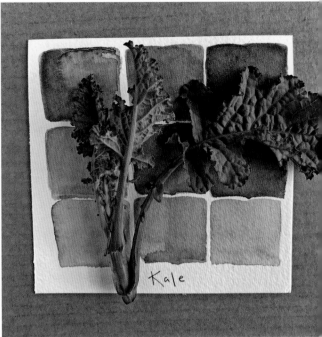

I usually label each color study, either with the name of the plant or with a personal observation that captures my mood that day, or something about the colors. If you want, document your color study by snapping a photo of your botanical on your completed painting once it's dried. This is an excellent way to check your work; a camera (and by camera, I mean smartphone) objectively captures what's there, instead of what we think we're seeing. And the photos become a record, a journal of sorts, tracking color, bloom, and season.

Each day I dance with the process, back and forth from painting to photo to painting, until I get as close to an accurate expression of the colors I see in a blossom, a leaf, or a seashell as I'm going to get. Then the light shifts and I'm back to square one. But when I do capture a color match, a pleasing, even joyful "chime" resonates throughout my entire being. Whether your practice becomes a warm-up exercise for further creative work or a mindful meditation that instills a moment of calm in a busy life, let color and nature refresh your senses.

What Do You See?

A Beautiful Distraction

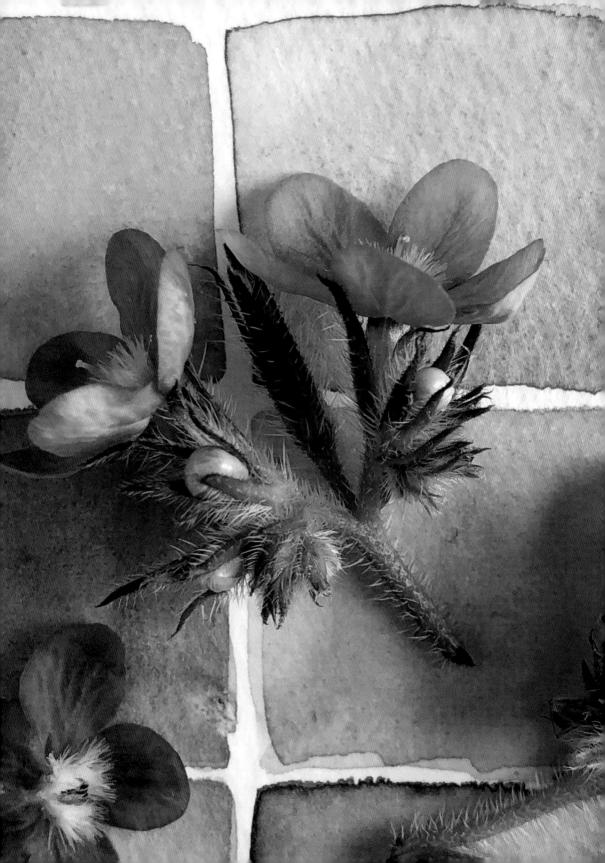

A garden makes room for our human impulse to organize while also offering us a means to comprehend wildness. Gardening is a humble practice, fraught with snails, failure, and loss, that also holds the promise of transcendent moments of exquisite beauty. It helps us to make sense of nature and find our role in ongoing creation.

My garden is a beautiful distraction that taught me how to cultivate a daily practice. Along with joyous highs and days of celebration, these past several years have held plenty of hard, noisy, and broken parts. To do something—anything, really—on a daily basis is to court tedium. Sometimes, all I can do is ride out the doldrums and watch for the next lifting wave of wonder and awe. It always, *always* arrives. My practice is the walk between this day and that.

I guess what I'm saying is: Pay attention to your life, including the uncelebrated, the overlooked, and the weedy parts. Look with heart and compassion, embrace the broken and the beautiful. Then share what you see with others. Our world needs your perspective.

About the Author

Lorene Edwards Forkner is an author and speaker whose work centers on exploring the wonders of the natural world. She writes a weekly gardening column for the *Seattle Times*, is the author of seven gardening titles, and is the former editor of *Pacific Horticulture* magazine. Lorene lives in Seattle, Washington, where she avidly tends her beloved garden throughout the year. Find her online @gardenercook.

Further Reading and Resources

regularly look to the following writers and creators to spark inspiration and uncover delight.

Dunn, Rae. *In Pursuit of Inspiration: trust your instincts and make more art*. San Francisco: Chronicle Books, 2019.

Fetell Lee, Ingrid. *Joyful: The surprising power of ordinary things to create extraordinary happiness*. New York: Little, Brown Spark, 2018.

Kleon, Austin. *Steal Like an Artist: 10 things nobody told you about being creative*. New York: Workman Publishing, 2012.

—. *Show Your Work!: 10 ways to share your creativity and get discovered*. New York: Workman Publishing, 2014.

—. *Keep Going: 10 ways to stay creative in good times and bad*. New York: Workman Publishing, 2019.

Jewell, Jennifer. *Cultivating Place: Conversations on natural history & the human impulse to garden*. A coproduction & podcast of North State Public Radio. https://www.cultivatingplace.com

Robinson, Mimi. *Local Color: Seeing place through watercolor with 12 practices*. New York: Princeton Architectural Press, 2015.

Schneider, Sally. *Improvised Life: a treasury of inspiring ideas*. https://improvisedlife.com.

Stanton, Philippa. *Conscious Creativity: look, connect, create*. London: Leaping Hare Press, 2018.

St. Clair, Kassia. *The Secret Lives of Color*. New York: Penguin Books, 2016.

Walker, Rob. *The Art of Noticing: 131 ways to spark creativity, find inspiration, and discover joy in the everyday*. New York: Knopf, 2019.

Art Supplies and Materials

Art Toolkit: https://arttoolkit.com.
Custom watercolor palettes, tools, and supplies to take your art practice on the road

Daniel Smith Watercolors: https://danielsmith.com
Watercolor pan sets, tubes, paint sticks, and dot cards, as well as brushes, papers, and instructional videos

Dick Blick Art Materials: https://www.dickblick.com
Huge selection of paints, brushes, papers, and more

Explore the exciting world of handmade watercolor: search by keyword

Seed Sources

Easy to Grow Bulbs: https://www.easytogrowbulbs.com
Bulbs, bare root and potted plants, Anemone corms

Floret Flower Farm: https://www.floretflowers.com
Seeds, bulbs, books, and helpful how-tos

Hudson Valley Seed Library: https://hudsonvalleyseed.com
Artful seed packets and detailed planting information

Renee's Garden: https://www.reneesgarden.com
Vegetable and cutting garden seeds, saffron crocus

Select Seeds: https://www.selectseeds.com
Seeds and plants

Uprising Seed: https://uprisingorganics.com
Seed suppliers and stewards of seed diversity

Acknowledgments

This book was born in the dark and brought into the light with the help and tending of many.

Enormous thanks to my agent Leslie Jonath for gently pushing me to dig deeper, craft a personal narrative, and for encouraging me to be vulnerable and brave. And to my editor Shawna Mullen, who recognized a book ready to be born, and the entire editorial and design team at Abrams whose keen eyes helped to bring my words and paintings to life on the page.

The community that's formed around my daily Instagram feed is precious to me. I am deeply grateful for the places this practice has taken me and the spaces I get to share because I picked up a brush and concentrated on paying attention.

To my beloved gardening kin who grew me into the gardener I am today—too many to mention and an always growing band of soil sisters and brothers—thank you for generously sharing with me your knowledge, your brilliant plantsmanship, and an abiding love for the natural world.

Finally, to James, thank you for our adventurous life and making time for me to write, write, write. Honey, I love you.

Lorene Edwards Forkner

Gratitude (in no particular order)

Bluebirds and mason bees
Tomorrow, and the day after that
My garden, sourdough bread, grapefruit
Watercolor paints and an old brush
Anemones, my marriage
Sweet peas in a chipped family vase
Backyard berries
Winter daphne and brown sugar katsuras
My precious children and those they love
Twin boys, family, and loyal friends
Ice-cold gin and hot black coffee
Books, number 2 pencils, the sounds of words
Hope, health, and recovery
Wide skies and running fences